CAR ART IN CUBA

GILBERT BROWNSTONE

PHOTOGRAPHY BY
CAMILO GUEVARA

ART IN CUBA

Flammarion

CONTENTS

SOWING THE SEEDS OF
UTOPIA ON A GOLF COURSE

GRAZIELLA POGOLOTTI

The final victory of Cuban revolutionary forces, in early 1959, proved that the gradual establishment of a socialist state was a real possibility. Something extraordinary had occurred. In little over a year, a group of poorly armed men had managed to overthrow a well-trained professional army that had counted on military assistance from the US. Less than two years after this victory, the breakdown of diplomatic relations with the island's northern neighbor resulted in the Bay of Pigs Invasion. At the time, thousands of young men and women had left towns and cities for remote rural areas, to assist with the literacy campaign. Upon their return, they wondered what else they could do. Now it was time to study. The country was calling for doctors, engineers, and teachers. But, despite this urgent need to staff the established professions, it was decided that no talent, even artistic, should be left to its own devices.

The breakdown of diplomatic relations between Cuba and the US meant that American officials, administrators, and managers returned to the States. Space was now available at the former Havana Country Club, an exclusive golf course previously frequented by the elite. At this quiet location on the banks of the River Quibú, work commenced on the Escuelas Nacionales de Arte (ESN, or National Art Schools).[1] The climate at the time called for a modern design, in a departure from arid functionalism. It was to be a symbolic image of what the country aspired to be. Overseen by Cuban architect Ricardo Porro, two other enthusiasts set to work: the Italians Vittorio Garatti and Roberto Gottardi, who had been influenced by the architectural revival in postwar Italy. It was an investment of monumental proportions; nevertheless, more than half a century later some buildings are still incomplete. Although only ever half-finished, they have remained in constant use.

These facilities have played host to a huge number of young men and women who, with music, dance, theater, and the visual arts, have shaped the art of modern Cuba. Overcoming all kinds of obstacles, the political desire to safeguard nascent talent was realized. Through culture, the country managed to reclaim one of its most essential rights.

There were a handful of artists in Cuba at the time who, against the odds, and in the face of poverty and social indifference, threw themselves into developing their art. With an avant-garde spirit of revival, immersed in a partial and overdue modernity, they began to set their sights on broader horizons.

1 — According to legend, there was a famous afternoon when Fidel Castro was walking across the golf course at the Havana Country Club, a spot highly favored by the Cuban upper-middle classes. "What can we do with this place?" Fidel asked Che. The latter replied, "Turn it into social housing." "I have another idea," said Fidel: "an international school of art." So it was that the Instituto Superior de las Artes (ISA; previously known as the Escuela Nacional de Arte, or ENA) came into being. It was the only international art school in the whole of Latin America to offer courses in the visual arts, dance, theater, and music.

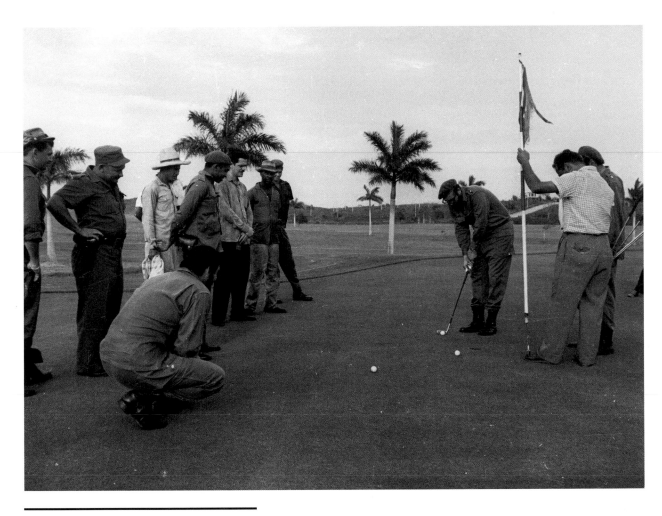

Alberto Korda, *Fidel Castro and Che Guevara Playing Golf at the Old Club of Colinas de Villarreal***, Havana, 1961.**

The island possessed a double and contradictory legacy. Its colonial and neocolonial heritage imposed the need to continue building a nation. Culture played an essential role in this, as did the country's urgent commitment to bridging the gap between wealth and the widespread poverty, between a highly refined intellectual elite and a people afflicted by illiteracy and precarious schooling. This burden was addressed by implementing a policy for the redistribution of wealth, and by mobilizing men and women who were prepared to show willing for a common cause. These included intellectuals who had been trained and educated both in Cuba and abroad. The movie *Memorias del subdesarollo* (Memories of

Underdevelopment), by Tomás Gutiérrez Alea, expresses the concerns of the time.

In order to give a voice to talented young people, many of whom had grown up in marginalized city neighborhoods or impoverished rural areas, it was necessary to build schools, organize a system of scholarships that would guarantee access to education, and rally young writers and artists to assist with designing curriculums and actively participate in teaching. The results became visible in the late 1960s, with the emergence of an artistic generation that in its vast majority hailed from rural areas.

This gave way to a whole new range of possibilities. The ballet, hitherto the preserve

**The Instituto Superior de las Artes
(Higher Institute of Art), Havana.**

of the elite, began to enroll children from orphanages. Following the inspiration of Martha Graham, the first modern dance schools were established. In order to safeguard Afro-Cuban folklore, the newly founded company turned to the Afro-Cuban community, many of whom went on to take center stage in new shows. In the second decade of the last century, the avant-garde works of Stravinsky helped to reveal the rich rhythms of Afro-Cuban music. Composers Amadeo Roldán and Alejandro Garcia Caturla incorporated these into their symphonies.

The most authentic expressions of urban culture can be observed in music and dance. Both transcend the barrier that has traditionally separated high from popular culture. They become interlinked in those creations designed to be presented on stage, and in the street improvisations we associate with different celebrations. After the Cuban Revolution, the ongoing presence of academics contributed to a development in the virtuosity of these disciplines, and the best of the tradition was safeguarded through the creative assimilation of a wide range of influences. As a result of the longstanding intercultural dialogue that stemmed from the French and Spanish occupation of New Orleans, jazz went on to acquire its own model in Cuba, opening the doors to a significant influence from The Beatles.

The history of the visual arts is more succinct. In the early nineteenth century, the San Alejandro Academy was founded as a legacy of the Enlightenment. The small handful of painters of the time followed artistic models being established by similar institutions elsewhere, essentially Spanish and Italian. A period of relative stagnation ensued until the emergence of the first avant-garde creations, in the 1920s. The young rebels of the time now set their sights on Paris. Despite the rise of Mexican muralism, they avoided the temptation to imitate and proceeded to forge their own language.

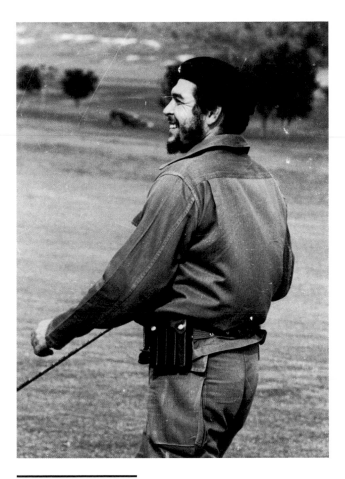

Alberto Korda, *Che Playing Golf at the Old Club of Colinas de Villarreal*, Havana, 1961.

With the birth of the Escuelas de Arte, they then turned their hand to teaching. The 1980s saw the rise of a generation of parricides, born under the sign of conceptualism. The democratization of the artistic education system enabled vocations to be safeguarded. These could now be developed, thanks to a government policy that sponsored those institutions, galleries, libraries, museums, and theaters that facilitated an essential dialogue with audiences. It is also important not to overlook the decisive role played by the establishment of three cultural industries that had not been in existence before the revolution. The production of musical recordings freed artists from the exploitation of record label monopolies. The publishing industry favored the dissemination of national and international authors. The emergence of the ICAIC (the Cuban Institute of Cinematographic Art and Industry) made the dreams of budding filmmakers a reality, as well as providing the necessary transdisciplinary link with composers, actors, and visual artists turned directors of photography.

Economic crises have weakened the institutional system fueled by the revolution as a whole. But its results still remain in the work produced by subsequent generations. History is not a succession of dreams and of miracles that follow in their wake, but comes into being thanks to the coordinated efforts of many within a context of efficient and realistic policies. Reality is transformed by the bond that links dreams with possibility. The path is forged, step by step, using a compass that is always set toward a relentless quest for human improvement. It is the reason for development, or a formula for survival, on this planet that suits us so well. ▬

AN INTERVIEW WITH CAMILO GUEVARA

GILBERT BROWNSTONE

Gilbert Brownstone: When did you first become interested in photography?

Camilo Guevara: When I was a child. I didn't have a camera then. It was difficult for me to take photos. I didn't want to force the issue. When I wanted to take on a personal project I preferred to borrow the equipment. Finally, at one point I managed to get my hands on a camera and started taking more photographs. At other times I've also helped others by teaching them photographic techniques. Ultimately, it's a kind of pastime. I also took courses in technical photography at university, which obviously does not have much to do with artistic photography. But it was there that I started, that I learned the rudiments of photography. Then I taught myself artistic photography, since it appealed to me as a hobby; it's a need I have to satisfy. That's it, basically. Nothing more. I make no great claims. My aim is to practice photography because it interests me, because I enjoy it.

G.B.: Your father took a lot of photographs, didn't he?

C.G.: Yes, but very sadly his collection—all the photographs he took—has not been preserved, though in fact he himself was not that concerned about safeguarding his work. What appealed to him was the process of photography. He took photos partly in order to leave a record of the time he lived through,

the places he went, the things he became involved in. It was also a kind of tool for him, because on his travels, in his life, he employed photography not just artistically (I think some of his photographs are very interesting from an artistic point of view), but also to document and to consolidate what he'd learned. For example, he was fascinated by archaeology and anthropology. He went to places that intrigued him, and he took photographs of these places, people, and spaces. He employed photography for various purposes. But unfortunately he did not protect his materials as a professional photographer would. He did not really devote himself to photography. At one time my father took photographs for an Argentine news agency, covering the 1955 Pan-American Games in Mexico City. He was a photojournalist, but in general photographs such as these are handed over. There was an exhibition entitled *Che The Photographer* that showcased his photographic work and toured a number of places worldwide. There are only a few of his photographs still around, but they do exist.

G.B.: And you, what are you looking to achieve in your photographic work?

C.G.: There was a time when I did a lot of macrophotography, using a magnifying glass because I didn't have a proper lens. But that did not hold me back. What interested me was seeing the results, which I enjoyed from an

aesthetic point of view. I took pleasure in it. I produced several pieces until, one day, I annoyingly mislaid the camera. Nevertheless, in these works I concentrated mainly on composition rather than anything else. Deep down, I tried to say something through the composition. These images were connected to a project for which I was trying to exploit and explore possibilities in line with my own artistic vision. I've been lucky in that a number of people have shown an interest in my work, and I've had a few exhibitions—here, in Cuba, and in other parts of the world too.

G.B.: Lastly, could you explain what you're doing right now?

C.G.: At the moment I have another job, so I have very little time to devote to photography.

And photography does require time, depending on the type of work you do. The fact is that I'd like to take advantage of every opportunity. There is so much one can do with photography. I practice it because it interests me, but I don't really have enough time at my disposal, or sometimes even enough space. I work in one place; from there I return home, and from home I go back to work, meaning that I really have to concentrate and utilize all the potential this reality offers me. So the projects I work on often have to do with my environment. ▬

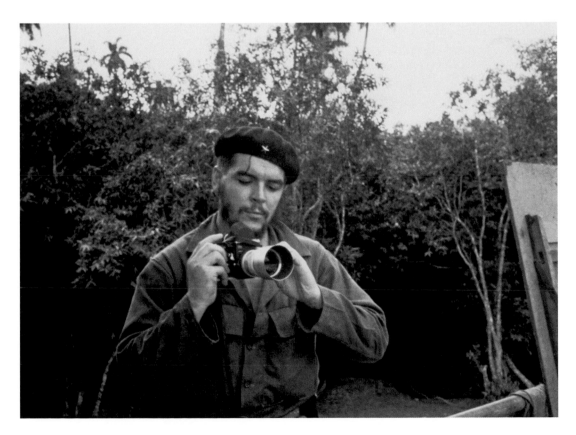

Roger Pic, *Che with a Camera*, 1963.

AN INTRODUCTION TO
CUBAN CULTURE

GILBERT BROWNSTONE

It is impossible to approach the subject of Cuban art or Cuban artists without attempting to understand the important role that culture has always played in Cuba, even prior to the revolution. How did this Caribbean island of fewer than twelve million inhabitants produce so many major artists in every discipline? Cuba has always been a land where different ethnicities have mixed, and one that has an extremely dynamic culture. Throughout the twentieth century, cultural networks were created not only in Havana but in the provinces too. And this was true in literature, theater, opera, ballet, music, and cinema, as well as in the visual arts, which boast some first-rate collections, such as those assembled by the wealthy businessman Julio Lobo and the Bacardi family. Cubans excel in every discipline. Many artists of international renown have also come to Cuba to perform, from Sarah Bernhardt to Martha Graham, turning this island—the pearl of the Caribbean—into a very special place.

Yet, until the arrival of Fidel Castro, Cuba's impressive cultural potential remained the preserve of an elite. In 1953 a quarter of the island's inhabitants were still illiterate, and only 45.2 percent of school-age children were in education. This then was a culture enjoyed solely by a privileged few. Moreover, in the 1940s, during Prohibition, Cuba and—more particularly Havana—became a Mafia outpost, and the brothel of the United States.

With the advent of the revolutionary regime, education was prioritized, and a sustained pro-literacy campaign was launched. In the wake of the general democratization of culture, more and more Cuban people gained access to education and culture, with free schooling, and free entry to shows, concerts, and museums. Great stress was laid on cultural development, and a raft of political measures allowed Cuba to live up to the celebrated dictum of José Martí,[1] founder of the Cuban Revolutionary Party, liberator and national hero, that "acquiring an education is the only way to become free."

Apart from my experience in Cuba over more than fifteen years, I have worked with Cuban cultural institutions and carried out interviews not only with artists, but also with other art professionals: museum directors, art critics, and gallerists, in both public and private sector institutions. If the present volume deals solely with culture in Cuba, the political questions raised extend far beyond issues of cultural policy.

1 — José Julián Martí Pérez (born January 28, 1853 in Havana, died May 19, 1895 at the Battle of Dos Rios). Acknowledged as the intellectual author of the liberation of Cuba. A political thinker and an eminent writer, he was also the chief precursor of the literary movement known as Modernismo. Many facets of his intellectual activity as a poet, teacher, diplomat, orator, and ideologist of the revolution are contained in the twenty-eight volumes of his complete works.

Culture as a Pillar of the Revolution: The Fight against Illiteracy, and Culture for All

Between 1959 and 1961, in the midst of radical socioeconomic upheaval and on the eve of the embargo spearheaded by the United States against Cuba,[2] several organizations came into being: the Instituto Cubano del Arte e Industria Cinematográficos (ICAIC), La Casa de las Américas,[3] and the state printing works. The status of the National Library and the Escuela Nacional de Bellas Artes San Alejandro were both consolidated. In addition the National Ballet was reestablished under the direction of Alicia Alonso, while the National Theater of Cuba started to take shape and a symphony orchestra was set up.

In parallel, a training program for art instructors was started. The most significant Cuban cultural enterprise was, however, already underway: the literacy campaign. In less than a year, upwards of 270,000 volunteers from all four corners of the country were teaching nearly 700,000 other inhabitants to read and write. This total transformation turned Cuba into a country with one of the highest rates of literacy in the world.

On June 16, 23, and 30, 1961, in the National Library in Havana, Fidel Castro, together with other revolutionary leaders and many Cuban writers and artists from various areas, held a round table to air the issues, doubts, and problems surrounding the creation and circulation of ideas, and the production of artistic and literary works. The relationship between the fledgling revolutionary institutions and the intellectual community was a central issue. On the final day of the talks, Fidel Castro gave a speech that has since become known as the "Palabras a los intelectuales"[4] (Speech to Intellectuals), which is regarded as the key statement of cultural policy for the revolution. Fidel proclaimed: "The Revolution then cannot seek to stifle art and culture, since one of the goals, one of the fundamental goals of the Revolution is to develop art and culture, precisely so that art and culture can become the heritage of the people in the true sense." He then added the much-quoted phrase: "Within the Revolution, everything; against the Revolution, nothing." In August 1961, at the Habana Libre Hotel, a Congress of Writers and Artists was held; this led to the creation of the Unión Nacionale de Escritores y Artistas de Cuba (UNEAC).[5] Purposeful and organized, other intellectuals threw themselves into what became a cultural ferment.

In 1962 the art schools at Cubanacan were created;[6] in 1976 they became the ISA, the foundation stone for a program of art teaching reform that soon spread throughout the country. Children and young people, who, owing to their background, could never have dreamed of a university education could thus

2 — On January 25, 1962, the Organization of American States (OAS), under pressure from the United States, voted by 14 to 6 (Argentina, Bolivia, Brazil, Chile, Ecuador, and Mexico) to expel Cuba. All commercial, diplomatic, and air links between the island and other countries of the continent were severed (except with Mexico and Canada). The embargo ("El Bloqueo" in Spanish) was pursued by the Western allies of the United States, except Canada, France, and Spain, which thus exposed themselves to sanctions. Cuba found itself almost completely isolated. In 2014 the losses suffered by the Cuban economy on account of the embargo reached more than $116 billion.

3 — La Casa de las Américas (The House of the Americas) is a cultural organization created in Havana on April 28, 1959 to further cultural, literary, and scientific interchange and osmosis between the Latin American states and the Caribbean. Engaging in activities to promote cultural awareness, it organized concerts, competitions, exhibitions, festivals, and seminars.

4 — See the discussion between Abel Prieto, minister of culture, and Gilbert Brownstone published in the *Journal des Arts*, no. 203, Nov.–Dec. 2004, pp. 18–19; and Fidel Castro and Ignacio Ramonet, *My Life: A Spoken Biography* (New York: Scribner, 2006).

5 — The UNEAC is an organization promoting culture and art, founded on August 22, 1961 by the poet Nicolás Guillén. The visual arts section alone numbers some 1,200 members, with 850 based in Havana.

6 — June 7, 1962 saw the official inauguration of the first courses at the Escuelas Nationales de Arte (ENA, or National School of Art), an educational institution that had not existed until then. The ENA started with three specialties: visual art, music, and the dramatic arts; these were later joined on the curriculum by dance and audiovisual communication. On July 29, 1976, the ENA became the Instituto Superior de las Artes (ISA, or Higher Institute of Art). The coordination of the ENA project was placed in the hands of architect Ricardo Porro, who turned to Italian architects Vittorio Garatti and Roberto Gottardi to collaborate with him. The five buildings they designed are regarded as the most exceptional architectural complex erected during the revolution.

begin learning and mastering different means of artistic expression. The Cuban cultural model is characterized by a principle of mass democratization, designed to involve all, without distinction. Especially for someone from the lowest rung of the social ladder, studying the visual arts in nations other than Cuba has remained extremely difficult. In Cuba, there are no fewer than fifty art schools, scattered all over the country, their aim being to prevent talent falling through the cracks. Thus, if a child— whatever their social origin and wherever they live—possesses a gift for music or visual art, they must be permitted to study. This approach has enabled unprecedented numbers to embark on careers as musicians, dancers, and visual or performing artists.

For the artist Choco, "The revolution taught us, educated us, it paved the way for us to sit for our diplomas, to study the arts, and then to teach them to others." The majority of the artists I interviewed for this book stressed the importance and uniqueness of art education in Cuba. As Sandra Ramos remarked: "Cuba's system of art education is completely different from that in other countries: a well-organized system that channels a child's talent from their earliest years, with the establishment of elementary art schools in various regions throughout the country. Thus talent could be unearthed in these areas, from childhood, in dance, as well as in visual art and music."

Cuban artists are thus almost all the product of an art school and of the education they received there. The artist Juan Roberto Diago Durruthy puts it in the following terms: "Culture is one of our most significant successes, and our slogan has always been 'Culture is the hallmark of the nation.' Since the beginning it has been inclusive, open to all…. Many young people came from the countryside to study in Havana and a National School of Art was set up. Today many major artists come from outside Havana, such as Nelson Dominguez and Roberto Fabelo from Camagüey, or Manuel Mendive, who grew up in the impoverished district of Marianao."

The second principle behind the Cuban cultural model concerns the formation of a cultivated audience, one receptive to all the manifestations of art, even to those considered relatively sophisticated. The idea is to ensure that the masses possess the capacity to appreciate and to master the codes of art. Cultural events such as classical ballet, experimental theater, concerts, exhibitions, and art, dance, and architecture biennials, as well as book fairs,[7] are organized countrywide, and have been instrumental in keeping the public informed. Imbued by their culture, Cuban audiences are very demanding of their artists. Exhibitions draw huge crowds, so that, with each new presentation of their work, artists have to be at the top of their game. Faced with such an astute public, Cuban art cannot drop its guard and has to reinvent itself constantly.

During one of our discussions, Fabelo reminded me that the first work to be published in Cuba by the national printer in about 1960 was Miguel de Cervantes's *Don Quixote*. So this first publication was not a political treatise, or a handbook for militiamen, or a pamphlet of revolutionary indoctrination, but a universally hailed masterpiece. It also inaugurated the "Library of the People" imprint, featuring classics of world literature, a collection that soon included César Vallejo, Rubén Darío, and Pablo Neruda.

The policy of allowing the greatest number of people access to knowledge was attained through many and varied measures, such as the creation of a system of cultural centers, publishers, art organizations, and institutions, posing a considerable challenge to Cuban culture. The aim was to build a system that would allow people to educate themselves. The policy of facilitating cultural access resulted in free or very cheap entrance to cinemas and museums. Greatly

7 — The Havana Book Fair, the most important publishing event in Cuba, was launched in 1982; originally it was held every two years, becoming an annual event only in 2000. Each year a country is invited as guest of honor, and the fair pays homage to personalities from the world of letters. The main venue for the fair is the historic site of Morro-Cabaña, and each year it attracts more than a million inhabitants of Havana that is to say, more than one third of the capital's population. After Havana, the fair moves to all the provinces, making it possible for Cubans to acquire books and other publications at moderate prices.

The Wifredo Lam Center, Havana.

to its credit, the fact that this small country strove to support its cultural policy as much as it did also had significant democratic impact. But we also know that the social recognition of creators, and the connection between the creators, artists, and access to art—that is, for society at large—is not an easy thing to achieve, because it calls for considerable resources. The debilitating economic difficulties and instability suffered by Cuba, in particular on account of the US embargo, are a matter of record. When cuts are to be made in a state's budget, it is always culture and educational and cultural projects—those deemed "unproductive" in economic terms—that are the first to be affected. In spite of this, Cuba places culture at the heart of its national resistance. The Cuban Revolution ascribed a crucial function to culture—a function that culture has perhaps never performed anywhere else.

The Cultural Challenges of the 1980s and 1990s

After the new regime had taken a few years to settle, there followed a phase of institutionalization that ushered in, as it so often does, an era of questioning and challenge. In 1989, as the Socialist bloc in Eastern Europe fell apart, Cuba, if it wanted to survive a crisis that hit it full on, had to reimagine its economic model. The break-up of the Soviet Union caused a sudden halt in the economic support it had been providing to Cuba, sparking major upheaval. It was against this backdrop that a more critical artistic environment, in ideological and social terms, emerged. Contradictions and divisions appeared between artists and the powers that be.

The upcoming generation turned to new practices, with, in particular, forays into interdisciplinary projects and interventions in the public arena, with the aim of transcending the aesthetics of the preceding decade. Though painting, drawing, photography, sculpture, objects, and installations continued to appear, many artists earned their reputation through happenings, actions, and interventions in public spaces, which began to affect and even defy Cuban cultural institutions. For Nelson Herrera Ysla:

Wifredo Lam,
Satan, **1942**
Gouache on paper,
3 ft. 6 in. × 2 ft. 10 in.
(106 × 86 cm)
Museum of Modern Art,
New York.

What gave artists their superior status was the fact that they could regard themselves as it were as the critical consciousness of society, deconstructing the dominant ideology, distancing themselves from their traditional cultural roots, and fostering the reconfiguration of vernacular codes and of kitsch…. It might be affirmed that their art became contingent, journalistic in character, and that it occasionally succeeded in short-circuiting the information and communication channels deployed by the State. Educational, social, cultural, and political institutions were all subjected to a stinging critique, as was the system of art itself.[8]

8 — Nelson Herrera Ysla, "Contemporain Cubain," in exh. cat. *Hasta Siempre, Ajaccio à l'heure de Cuba* (Milan: Silvana / Ajaccio: Palais Fesch Musée des Beaux-Arts), p. 53.

The Ministry of Culture and institutional networks generally seem, however, to have fostered this movement by providing backing to art centers and to national and international exhibitions. In 1983, the executive committee of the Council of Ministers authorized the creation of the Centro de Arte Contemporáneo Wifredo Lam, whose remit covers the research into and the dissemination of the artist's oeuvre, as well as objectives of a wider scope. From the very outset, the center embarked on promoting contemporary art in developing countries, organizing one of the most significant events in the region, the Havana Biennial, the first of which was held in 1984. Cuban art was

thus confronted with international art, and the Biennial paved the way for a Cuban art that was sometimes considered to be extravagant, polemical, or disrespectful. On November 15, 1986, the National Council for the Visual Arts of the Ministry of Culture (CNAP) inaugurated Fototeca, an institution set up to manage the Cuban photographic heritage and to organize regular exhibitions. The Centro del Desarollo de las Artes Visuales (CDAV) opened on Havana's Plaza Vieja in 1989. This state institution promotes work by emerging artists who explore new forms.

The island of Cuba has always been a nation of migration. After receiving a bursary at the age of twenty-one to study in Europe in 1923, Wifredo Lam returned to his native island only in 1941. Countless Cuban dancers, musicians, and painters also left the country to embark on an international career. The exodus of the 1970s, 1980s, and—especially—the 1990s can be also explained by the fact that many Cuban artists had attained such a level of competence that they dreamed of working in countries whose economic system might allow them to exhibit and sell to an international public. This is perhaps the other side of the coin of the Cuban education system. For the artist Esterio Segura Mora:

The generation born in Cuba in 1970 was the generation with the best opportunities of all. More than ten years after the victory of the revolution we had devised an evolutionary process, to the point that certain components were firmly in place, especially in the domain of education. We had had the benefit of land reform and literacy programs. At that time I was lucky enough to go to school in a solid educational system in the town of Camagüey. This was combined with my father's decision to allow me to become an artist, and with the fact that it was possible for a child, whose family was in no way wealthy, to obtain a place at an art school where my first brushes were made by Rembrandt, my first oil paints by Rubens, and my paper by Canson. Our education was almost multidisciplinary, not only in the arts, in the visual arts: we grew up and embarked on the early years of our lives as artists with dancers, musicians, actors, with contacts in the cinema, and with many cultural events.

As we have already noted, Fidel Castro, in his "Speech to Intellectuals," said that artists had to be free to create. Tensions between the latter and the government, however, certainly exist. As Cuban art critic Gerardo Mosquera has observed:

The movement that began within the visual arts [in the 1980s] spread throughout Cuban culture.... For the first time since 1959, cultural discourse became separate from "official discourse." It established a distance, cultivating its own plot—to the extent possible in a centralized and authoritarian country—and evolved into the critical culture it is today ... because the artists remain non-conformist and interested in free artistic investigation.[9]

Dissension can also break out because the museums, art centers, and galleries must present their exhibition projects to have them validated by the ministry. Since no rules have been clearly laid down, however, permission tends to be handed out arbitrarily. What is forbidden today might perhaps be permitted tomorrow. Thus, if artists remain free to create in Cuba, they are not completely sure which works are going to be exhibited.

As Esterio Segura Mora puts it:

The "Speech to Intellectuals" did not define a procedure for obtaining proficiency in art, but a political standpoint. The "Speech to Intellectuals" defined an attitude for Intellectuals as individuals, the thing that worried the government most. It meant that, to be safe, we intellectuals had to back the revolution. It practically amounted to a constitutional law for intellectuals: what we do, write, and say could be for the revolution, but not against the revolution. We might not be for the revolution, but we couldn't be against the revolution. There were subjects that the revolution did not encourage—for example, eroticism in a work, images of the market, images of consumption, things that were fashionable at the time, because at this period in the 1960s in the United States there was the pop art movement and the entire American people were talking about commercialism, about advertising.

Politics is a topic without which, I'd say, no Cuban, no conscious individual in Cuba can live. Cuba was isolated:

9 — Gerardo Mosquera, "New Cuban Art Y2K," in Holly Block, *Art Cuba: The New Generation* (New York: Harry N. Abrams, 2001), p. 13.

for certain concepts, we were saved from the international political world, and, for others, we were isolated from the international political world, but in a way that gave us political, social, and cultural values piloted by politics that maintained us in this situation. All excess is nefarious. In Cuba, we had an excess of politics and of political positions in order to keep things in place, and the balance was lost. The balance that existed in the 1970s, 1980s; the nobility of a romantic idea, of a healthy idea, healthy education, healthy growth, all this disappeared in the 1990s during what was called the Special Period, but one could say that Cuba lived in a special period for the whole time of the revolution, because it was a special period in the history of Cuba in general.

On the cusp of the twenty-first century, Cuban artists started to tackle themes such as migration, geographical destiny, history, and identity, in their works, increasingly referring to the images and codes of Western culture. Simultaneously, the profound economic and political crisis that struck the country in 1989 fueled both the wholesale departure of artists and transformations in the visual arts. Still, in spite of the problematic circumstances dictated by the Special Period, Cuban art conserves its utopian potential and is pursuing the process of catch-up inaugurated in 1980. The decade of the 1990s also witnessed the first great sale of contemporary Cuban art, when the exhibition *Cuba O.K.* was held in Düsseldorf, Germany. Henceforth, Cuban artworks began to find their way into the hands of international contemporary gallerists, collectors, and art curators.

Cuba in the New Millennium: Private Galleries and the Art Market

Until just a few years ago, all Cuban art galleries were run by the state, even if, for the art connoisseur, they appeared to function like private galleries. Directors could choose artists without interference, transferring 50 percent of sales revenue to the artist, with the remainder going to the state, but they remained public sector employees paid by the state.

Long directed by Luis Miret, the Galería Habana was up to then the only Cuban gallery with an international reach. It appeared at major art fairs, including the FIAC, Art Brussels, the Armory Show, and Art Basel. Miret contributed greatly to the organization of groundbreaking exhibitions and to the representation of Cuban contemporary art worldwide.

About four years ago, though officially prohibited in Cuba, private galleries—that is to say, those owned by private individuals—started springing up. The question of their status arose. To ensure their existence, they generally call themselves "artists' studios." They also take part in international fairs. This development was made possible partly by an upswing in tourism. Today Havana is a city undergoing one of the most marked increases in tourist numbers.

A further explanation for the upswing in the creation of these private galleries is the fact that Cuban art has been attracting informed collectors for decades. Not wishing to tempt fate, one can well imagine that this is a tendency that will continue. Today artists receive visits from tourists in their studios almost daily. Tour operators schedule trips to workshops and art centers, and the visual arts Biennial in Havana has become popular with tourists. Now tolerated, these new galleries are transforming the cultural landscape little by little.

With the arrival of the art market, the Cuban artists known as Generation 2000 find themselves in a completely new situation. Because today many artists work in response to market expectations, this phenomenon is already affecting Cuban art and it will continue to do so. Many of the artists I interviewed remarked on this recent change. Luis Gómez airs his fears:

It will all change gradually. It seems to me that art and artists are harbingers, harbingers of what will happen, and it does not always look good. I feel that what's occurring today in Cuban art is not encouraging. I'm not against the market; we work to earn a living. But the risk is that, instead of producing an artwork for oneself which later might meet with a response in the market, the artist thinks of a work for one market in particular. Cuban art is being homogenized.

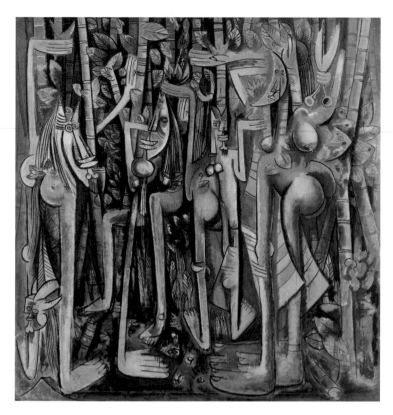

Wifredo Lam, *La Jungla* (*The Jungle*), 1943
Gouache on canvas, 7 ft. 10¼ in. × 7 ft. 6½ in.
(2.39 × 2.29 m)
Museum of Modern Art, New York.

I tackled the same question with Fabelo. He felt that

Money had a different meaning. There was a different vision. I had my diploma from the National School of Art, then from the ISA. The life I led was relatively comfortable. It was not a life full of conveniences because our viewpoint was different. In daily life the Cuban peso possessed a different value, and the art market did not have the emerging role it has at the present time. For us, attaining success was conceived of in quite another way. Not acquiring money, or positive results from an economic standpoint, or the going rate for our works. Our vision was perhaps a little more romantic, more idealistic. Similarly, our drive did not come from the hope of earning a lot of money—without denying the importance money has always possessed—but at the time it was not as crucial as it is today. The market has acquired huge importance. One has to be realistic, form part of certain circuits, and that comes from selling one's work, from getting works into galleries. In former times, subsidies were far higher than they are today, because the economic conditions in the country were different. There were many things on the horizon. Materially speaking, living standards were in general modest. Success had a different meaning for us then.

Reynier Leyva Novo has a more positive outlook:

In the 1980s, the art market was virtually zero. It was practically nonexistent. It was invariably people from abroad who pushed ajar doors that otherwise remained shut. The exchanges artists took part in were chiefly with Socialist countries. After a great migration among artists in the 1980s, almost all to Mexico, after the collapse of the Socialist order, the so-called Special Period, the legalization of the dollar, many factors, both political and social, created a favorable context, allowing artists to adapt to the market, and the market began to make headway in Cuba. Obviously it was the artists of the 1990s who unlocked the door to the market. And we, we found it open. I am persuaded that it's easier for us to enter the international marketplace than for earlier generations. Here, any young art graduate or student can work with a foreign gallery, can sell their work.

For artist Juan Roberto Diago Durruthy:

Today the situation has deteriorated a little because the economic impact on today's Cuba has been huge. Cuba is not the same. Cuba has been transformed. Today the situation on the ground is quite different from what it was thirty or fifty years ago. The social system remains inclusive. The revolution had been an engine, stimulating the cultural process. And, though it continues to back cultural projects, it's become harder. Resources on which one could once have counted no longer exist.

Finally, Glenda León thinks that things have changed a little, like everything else, for better or for worse:

I think the positive outcome is obviously that now Cuban art is better known outside Cuba, internationally, and I think this is something good for Cuban culture, and the promotion undertaken by galleries. The negative side is that there is a risk that one turns out art that is entirely commercial, becoming a kind of machine, a machine to produce works that sell. This is happening not only in Cuba (it's beginning now in Cuba)—it's underway all over the world.

One message comes over loud and clear in these testimonies about the transformations affecting the Cuban art market: people like Cuban art, and it arouses passion and curiosity.

During our conversation, Esterio Segura drew my attention to the fact that "from the 1920s to the 1970s, very few Cuban artists were recognized in the international arena. Only Wifredo Lam was exhibited at the Museum of Modern Art in New York. Now, however, there are at least nine Cuban artists in the collection of MoMA."

During all those years when Cuban art was almost unknown abroad, it should be noted that there were some knowledgeable collectors who were purchasing Cuban art, in Germany and in the United States. The history of the Ludwig Foundation in Cuba is instructive in this respect. In 1990 the American collectors Carole and Alex Rosenberg, together with a group of artists and art professionals, filed a lawsuit to protect artistic exchange with Cuba against the American embargo, citing the First Amendment. Following the US government consent decree permitting art dealers to travel to Cuba to make purchases, Carole and Alex Rosenberg were invited as guests to the 3rd Havana Biennial. They then took the decision to take American art to Cuba, and Cuban art to the United States, taking part in conferences, organizing seminars and exhibitions, and sharing their expertise. They also opened their house to Cuban artists visiting the United States and shared their contacts. At about the same time, another famous collecting couple from Germany became interested in Cuba. Peter and Irene Ludwig, who had founded the Ludwig Museum in Cologne, which contains one of the finest collections of 1960s American art in Europe, became curious about Cuban art. After visiting the exhibition *Cuba O.K.* in Düsseldorf, they began to assemble an exceptional collection of the island's art. Peter Ludwig even dreamed of setting up a Museum Ludwig in Havana. Conditions during the Special Period, however, made it impossible to institute such a collection, and instead it was decided to establish a foundation with the mission of safeguarding and promoting Cuban artists both at home and abroad. The Ludwig Foundation of Cuba (LFC) was set up in 1995, with Helmo Hernandez as its president.

By 2001, Havana could boast two flagship national art museums. The first is devoted exclusively to Cuban art from its origins to today. The second—very diverse—museum is dedicated to art worldwide, and includes a splendid collection of French eighteenth-century art that, alongside that in Argentina, is among the most outstanding in South America. In addition to the Wifredo Lam Center, the CDAV (Centro de Desarollo de las Artes Visuales) and Fototeca also exhibit Cuban art. Then, finally, there is the Factoría Habana, a vast space dedicated to contemporary art that belongs to the municipality of Old Havana. The representation of contemporary art by state institutions in the capital is thus significant and worthy of a European capital. The museums mentioned above are dedicated solely to modern and contemporary art, but there is, in addition, a network of heritage museums, including the Museo Nacional de

Artes Decorativas and the Museo Napoleónico in Havana; the latter houses an important collection and is the most significant museum dedicated to Napoleon outside France.

With its art schools, art centers, and private initiatives, the status of Cuban contemporary art is today firmly established.

Cuban Art

Contemporary art in Cuba has emerged from a combination of influences, not least of which is the island's own artistic heritage from the last century. The avant-garde reaction that arose in the 1920s introduced a new era in Cuban painting. The modern movement enjoyed its first and largest exhibition in 1927, under the aegis of the *Revista de Avance*.[10] The initiators of the Cuban avant-garde included Eduardo Abela (1889–1965), Víctor Manuel García Valdéz (1897–1929), Antonio Gattorno (1904–1980), Carlos Enríquez (1900–1957), Mario Carreño Morales (1913–1999), Marcelo Pogolotti (1902–1988), Leopoldo Romañach (1862–1951), and Armando Menocal (1863–1942). Drawing on surrealism, fauvism, and cubism, artists added Afro-Cuban elements familiar from their own culture. The following years saw the consolidation of the modern movement, in particular thanks to the first Salon of Modern Art in 1937. During this period, work by young artists offered the promise of a revival of Cuban art, which eventually bore fruit with the so-called Havana School in the 1940s. Leading figures in this movement were René Portocarrero (1912–1985), Amelia Peláez (1896–1968), and Mariano Rodríguez (1912–1990).

Victor Manuel García Valdéz, *Portrait of the French Engraver Elié Marquié*, c. 1933
Oil on canvas, 24 × 21 in. (61 × 53.3 cm)
Private collection.

10 — A journal of avant-garde culture published in Cuba between 1927 and 1930. Founded on March 15, 1927 in Havana, under the banner notably of Juan Marinello, Alejo Carpentier, and Jorge Mañach (also a publisher), it featured Cuban and foreign texts, and in 1927 set up the first exhibition of modern Cuban painting (*Exposición de Arte Nuevo*). The magazine featured the most innovative artists and ascribed especial importance to the Creole appropriation of the avant-garde movement, in literature and music as well as in the visual arts. In 1930, owing to the repressive climate that prevailed during the presidency of Gerardo Machado, it ceased to appear.

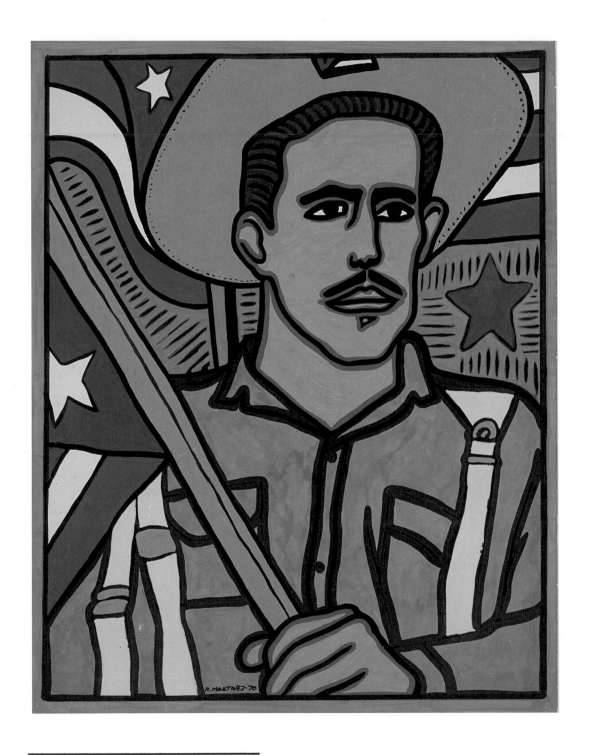

Raúl Martínez, *El abanderado* (*The Flagbearer*), **1970**
Mixed technique on paper, 29½ × 22⅜ in. (75 × 57 cm)
Farber Collection.

In 1942 Wifredo Lam (1902–1982) returned to Cuba after a lengthy sojourn in Europe, during which he had spent time in Picasso's studio. This event marked a turning point in Cuban painting. In 1943 Lam completed a work that brought him lasting fame: *The Jungle*, later acquired by the MoMA in New York (see p. 19).

In the 1960s, talented painters such as Raúl Martínez (1927–1995, the first Cuban pop artist), Servando Carera Moreno (1923–1981), and Antonia Eiriz (1929–1995) left a hugely important body of work that would exert a powerful influence over following decades. Alongside these figures, younger artists such as José Bedia (b. 1959), Belkis Ayón (1967–1999), Flavio Garciandía (b. 1954) also performed a key role in the avant-garde as painting started to follow new paths.

During the last thirty years, Cuban art has demonstrated its ability to channel the most significant currents of international art in individual and creative ways, all the while maintaining a critical position with respect to its themes in its effort to defend Cuban identity. As the 1980s dawned, topics such as migration, geography as destiny, history, and identity were increasingly taken up by Cuban artists, as were more sensitive subjects including homosexuality, masochism, and domestic violence.

The artist Rene Francisco Rodríguez describes how:

There exists a Cuban spirit in painting. There's a Cuban school, identified notably with a highly conceptual figuration—perhaps not a pure conceptualism, as in the 1960s in the United States, but an art that actually came from the school, thanks to teachers who taught us how to look at things intelligently. The point isn't to paint for painting's sake. For visual artists, the idea of taking up a piece of paper and a pencil was always: "Why am I doing this?" There's always the question "Why?" and this "Why?" continues to exist at the school. Then there's a quality in Cuban art that takes and applies this to context. Cuban artists might be compared with chroniclers, precisely because, to a degree, their art remains literary. It's very narrative. In fact, I reckon Cuban critics don't know how to analyze an abstract work. They're not like Brazilian critics who can stand in front of a frame with two lines and analyze it. They can construct an entire philosophy. We cannot; we possess an education in philosophical reflection, but it's very oriented toward narration and the rhetoric of what's happening. Our works always talk about something. And that's a great quality in Cuban art. That comes from art school. But one can see an evolution. A number of artists want to do something else. With the expansion of art in Cuba, many young people are doing good new work, and fully fledged artists remain active. The art produced between the 1960s and the 1980s was very specific, yet at the same time very universal. This is because Cuban art has to do with being human, with the conflicts of being human. It's as though there were something life-enhancing in Cuban art.

Sandra Ramos Lorenzo also talks about the impact of artists of the 1980s on the new generation:

Up until my generation, we had never considered art as a question of success, of career, of the market. We all did our work, we studied at the ISA without thinking about what was going to happen, without thinking that we were going to travel, because it was out of the question at the time; the only places one could visit were Russia and the Socialist countries. I also think it was a stroke of luck for my generation that, at that time, the Cuban art market opened up; there were so many exhibitions promoting Cuban art in Europe, in the United States, in Mexico. We were here, and moreover we had been trained by the generation of the 1980s, a generation that made immense strides in aesthetic and conceptual values, which they handed down to us. We also benefited a little from this historical moment and from the 1994 Havana Biennial, which was very significant. It launched an entire generation, including significant artists such as Kcho, Los Carpinteros, and so on.

One can thus safely say that Cuban art still has a Cuban flavor. There are many Cuban artists whose practice and art are much more international, and the border between Cuban art and international art might well dissolve. But it seems that what characterizes Cuban art is that artists think about their contexts, about social reality. And that has obviously generated a type of art creation clearly rooted in the country.

Reynier Leyva Novo confirms this observation:

With the opening up of the economy, and in particular following the death of Fidel Castro, art was deprived of many of these national paradigms. The Cuban context is a context full of problems, of conflict, but where there are no conflicts, there's no really meaningful art. That doesn't mean we're masochists, that we need to experience difficulties in order to create worthwhile art, but, really, the more problems societies have, the tougher their artistic practices are. That's true.

Cuba will change, and the art produced in Cuba will change too. The young will adapt and, owing to this process of adaptation, it may be that those characteristics of Cuban art that are connected to the country's particular history and culture will be lost. But, for the time being, Cuban art shows that it has been able to preserve its identity while adapting to new technologies and new ideas. Indeed, media such as photography, video, installation, and performance have succeeded in extending the reach of art, in Cuba just as in the rest of the world. The circulation of ideas and techniques has made its mark as much on this smallish, remote island as in other countries globally.

Around five or six years ago, an art critic undertook interviews with Cuban artists who had settled in Miami, who complained that collectors preferred to buy works from Cuban artists living on the island. Artists of Cuban origin living outside Cuba, in Mexico or the United States for the most part, also

The Centro de Desarrollo de las Artes Visuales, Havana.

The Academia Nacional de Bellas Artes San Alejandro, Havana.

proclaim their Cuban identity. The fact of living elsewhere, of cutting themselves off from their roots, however, has unquestionably occasioned visible changes in their oeuvre. In any case, that is how collectors have interpreted events. Can one talk about a single "Cuban art," and can one make Cuban art abroad?

There is something particular about Cuban artists. For many years, they have been able to travel and exhibit in foreign countries, yet artists such as Carlos Garaicoa and Los Carpinteros, who have studios in Spain, return to the island to work there too. Their roots are in Cuba. Their art is in Cuba. The situation there is quite particular to the country: young artists elsewhere find it very difficult to make a living from their work, whereas most Cuban artists earn enough to live from it—some more comfortably than others, of course, but they manage. There are a lot of problems in Cuba, but above all it is a privilege to be an

artist there. For Abel Barroso, "It's an unusual phenomenon. Many artists around the world have a second job that allows them to earn money. They teach or work in galleries. The great majority of Cuban artists, on the other hand, can earn a living from their art, thanks in particular to the works they sell through foreign galleries. If they teach, it's because they feel a duty to do so, and not something they do out of necessity."

Another remarkable characteristic is that a great number of Cuban contemporary artists— by no means all, but a significant majority— participate actively in efforts to improve Cuban society, offering energetic and generous support to their homeland. In order to repair the damage wrought by a succession of cyclones that devastated the island and to rebuild houses, Kcho funded a team from his own pocket, for instance. He also spent a year with his staff assisting the people of Haiti, and set up

**Belkis Ayón, *Sin título—
La soga y el fuego
(Untitled—The Rope
and the Fire)*, 1996**
Silkscreen, 2 ft. 4½ in. × 3 ft. 2 in.
(72.5 × 96.5 cm)
Private collection.

his Estudio Romerillo, a cultural community project.[11] Diago Durruthy, for his part, restored the California project with his own funds, even offering weekly lessons to the children. "I was doing what my teachers taught me…. I recall that, when I was studying at the fine art school, there were courses for children on Saturdays. As much as I can, I try to pass on what I've learned to others, as happened with me. Other artists do the same. It's really great," he told me. Lastly, Wilfredo Prieto's ambition with his project for the art center La Casona is to set up an art "laboratory" providing a program of regular exhibitions as well as a residence for foreign artists and exhibition curators.

Cuba is changing apace and opening up to the world. This is something that will necessarily affect the country's cultural fabric. Rocío García notes that "for a long time young people wanted to become artists because artists are privileged and earn money. Will this change? I think it will. Now fresh opportunities exist for the young to do something else with their lives." After two consecutive five-year terms, President Raúl Castro did not put himself forward as a candidate in April 2018, his first vice president, Miguel Díaz Canel, being elected as the country's new head of state. In addition, in July 2018 Abel Prieto, minister of culture from 1997 to 2012, and again in 2016, was replaced. These changes leave the future of Cuban cultural policy uncertain. Let us hope that everything that has made Cuba so rich may be both preserved and reenergized. ▬

11 — The Kcho Studio, also known as the Estudio Romerillo or the Museo Orgánico Romerillo, is a socially committed cultural project created by Kcho in 2013 in the El Romerillo quarter. The studio's aims include experimentation, development, the dissemination of the arts, and the promotion of understanding between peoples.

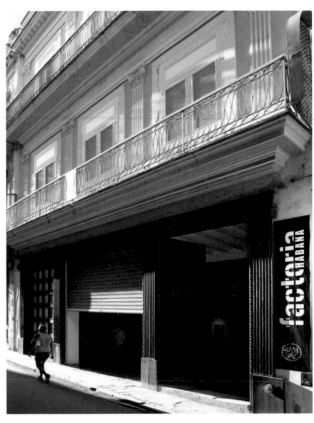

**The Fototeca and the Factoría Habana,
Havana.**

Never before has Cuban contemporary art boasted
such a diversity of aesthetic practices, so many
artists and emerging young talents, and so many events
and exhibitions. Contemporary Cuban artists favor an
interdisciplinary approach and are forever appropriating new
idioms, new media, and new techniques. For this book I have selected
over thirty artists. My priority was to offer a forum for artists living and
working in Cuba, even if several also have studios abroad. Some excellent
Cuban artists residing and working outside Cuba have been excluded. Portraits
of many other Cuban artists might have appeared, but for editorial reasons a
choice had to be made.

I was also especially keen to see these artists in their workshops in Cuba. The
conversations with thirty-two artists took place between December 2016 and
2017. Camilo Guevara, a Cuban photographer of great artistic sensitivity,
accompanied me to each studio meeting, capturing the artists in their
natural environment.

Finally, since I have so often defended the idea that artists
are better placed to explain their work than art critics
or historians, I opted to use the format of the
interview to present their viewpoints.

GILBERT
BROWNSTONE

CONTEMPORARY CUBAN ARTISTS

ABEL
BARROSO

I studied art during what is known in Cuba as the "Special Period," which was a difficult time, as there was a lack of materials to work with. In art school I guess these shortages made us feel only more motivated: with the little we had at our disposal, we found sufficient creativity to compensate for all these deficiencies and to make art. My generation trained during this Special Period, when many excellent artists were active. The artistic styles of this period were very varied. I think that, though each artist was influenced by his or her epoch, over time these different approaches acquired a certain universality.

At the ISA, during the Special Period, I started working with wood, since there was little else available. As an artist, a student, I would say: "To construct my own means of expression, I need to find a material that corresponds with my ideas, but it has to be something readily available in Cuba."

I studied printmaking at every level at the ISA, both elementary and intermediate. Whatever the specialty, hot metal or lithography, I was always interested in doing a completely unconventional type of printmaking, so I deviated from the norm and started experimenting. I always say that my training was in printmaking, but seeing my work it's clear it goes beyond this: there are installations and sculpture, and there are also ensemble pieces, such as the work I did with robots and computers. I have battled to break through the barriers of convention in printmaking, endeavoring to modify it and make it as contemporary as possible for the place where I live and work: Cuba. I travel a lot,

**Born in 1971 in Pinar del Río.
Lives and works in Havana.**

Pinar del Río

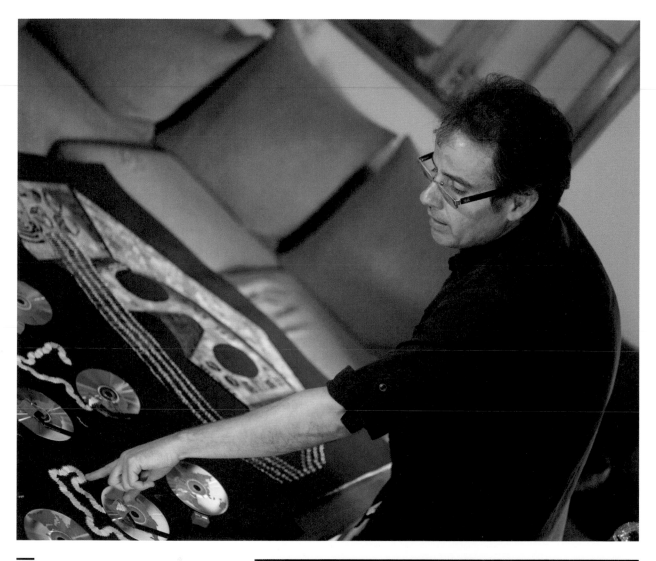

—
**Abel Barroso
in his studio.**

———
***Sala de Internet y
realidad virtual a la
cubana (Cuban-style
Internet and Virtual
Reality Room)*, 2017**
Mixed technique, variable
dimensions
View of the installation in
the Cuban Pavilion at the
Venice Biennale, 2017.

always picking up information, which contrasts with all the stuff I absorb from my background and, at the moment, from Havana, where I'm working, so that I can generate different ideas with each piece. My work covers themes including globalization, frontiers, migration, North and South—concepts that deal with the differences between countries and spaces, the lines of division between nations and peoples. In the 1990s, my work used to be much more contextual, whereas from the year 2000, when I started traveling, my work started to become universal. I've staged exhibitions in New York and Tokyo as well as in Madrid.

I don't speak Japanese; they'll never understand me. Through the visual image I try to establish a means of communication between entirely different worldviews, different cultures, different thought patterns; I constantly try to set up a conversation.

I've always tried to establish a dialogue. The work I do is not abstract. My exhibitions have titles, and I make sure that each show presents a different concept, dealing with topics that do not just touch me personally, as an artist, but affect many people around the world. In that way, people who live in different countries, in small villages, or in the middle of Europe can identify with the concerns of someone who comes from an island and creates an oeuvre within a particular historical, social, and artistic context. ▬

Abel Barroso
in his studio.

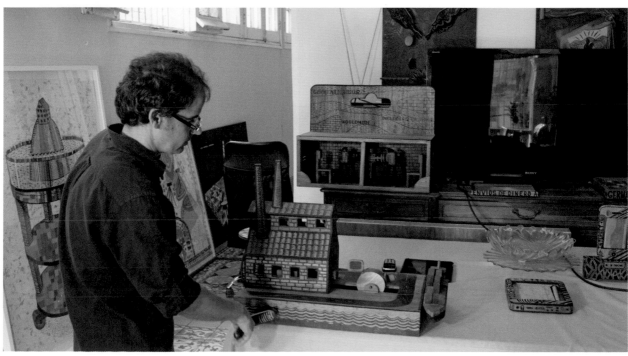

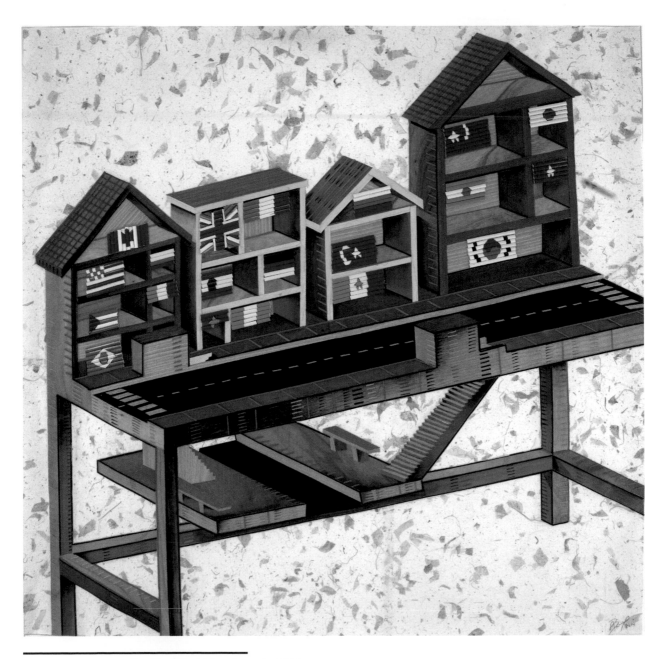

El mundo en una calle (The World in a Street), **2014**
Collage in wood on washi paper, 3 ft. 8⅞ in. × 3 ft. 9⅝ in. (1.14 × 1.16 m)
Fondation Clément Collection, Martinique.

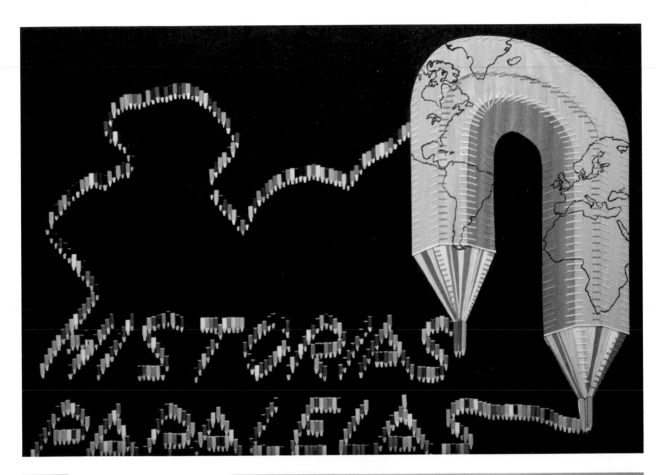

**Historias paralelas
(Parallel Stories), 2014**
Collage in wood on prepared canvas,
2 ft. 3½ in. × 3 ft. 3⅜ in. (70 × 100 cm)
Fondation Clément Collection,
Martinique.

Abel Barroso in his studio.

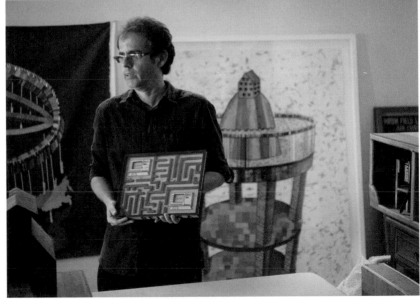

LUIS ENRIQUE
CAMEJO

**Born in 1971 in Pinar del Río.
Lives and works in Havana.**

Pinar del Río

I've been painting for a long time. As a child, I painted. I entered the School of Art when I was eleven or twelve, starting in Pinar del Río, following which I studied at the National School of Art and at the National Institute of Art. Then I taught painting at the ISA for ten years.

I began my body of work—the one people recognize—about twenty years ago. The main subject of my output is the city, the relationship between mankind and the different elements in the city that are an inherent part of us. It's an image of the city as seen by man and not a picture-postcard view. It is not the touristy city that others might choose to depict. I've always said that my work has more of a philosophical than a narrative viewpoint. I do not focus on any specific problem. My pictures owe a great deal to photography. They do not show situations; nothing truly happens in them. Instead I create atmospheres.

I work with just one color, with the idea of influencing the viewer's way of seeing. The point isn't to see reality as you want to see it, but as I present it to you—seeing everything as through a filter. What does this color evoke in you? What ideas does it awaken in you? Perhaps all my work is presented through a kind of nostalgic veil, with a certain melancholy, a sense of belonging that someone might feel toward a city. It is said that 75 percent of the world's population lives in cities. Aesthetic sensitivity, feeling, philosophy—it's all created in the city. The city is a huge urban, human jungle. Just like the gorilla might live in a great African forest, humans live in the Big Apple in New York. And the street furniture, the walls, billboards, posters, traffic lights, and cars are symbols of civilization, to the point that they've become an inherent part of humankind. —

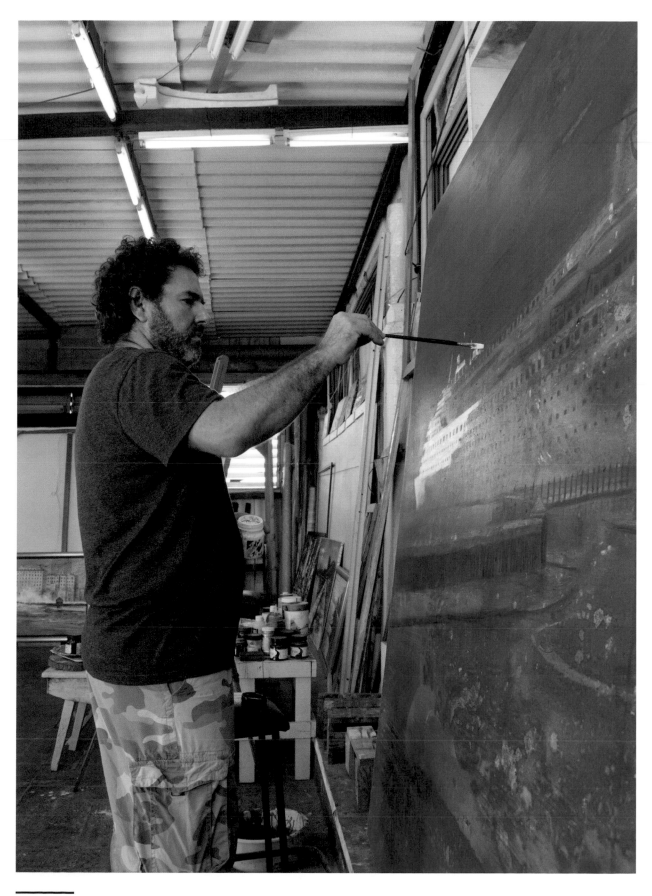

**Luis Enrique Camejo
in his studio.**

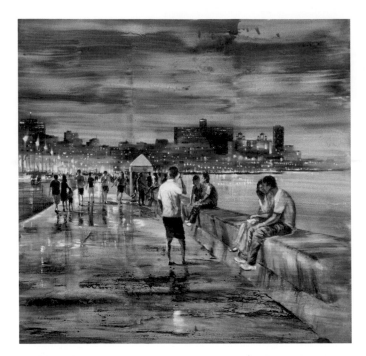

***Malecón Cohiba (Cohiba Jetty)*, 2014**
Acrylic on canvas, 6 ft. 6¾ in. × 6 ft. 6¾ in.
(2 × 2 m)
Private collection.

Untitled, from the series *Malecón, cadenas*
(*Jetty, Chains*), 2010
Acrylic on canvas, 6 ft. 6¾ in. × 6 ft. 6¾ in. (2 × 2 m)
Private collection.

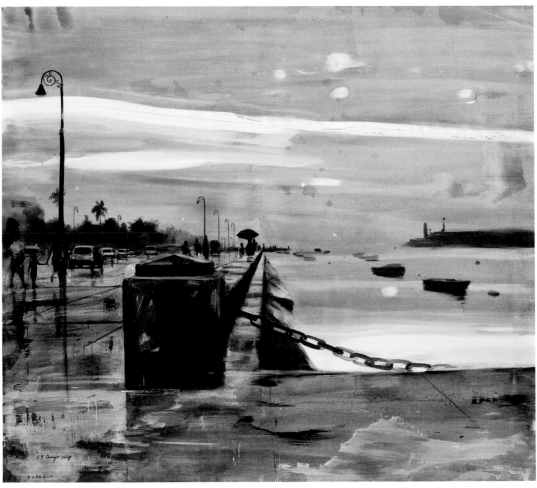

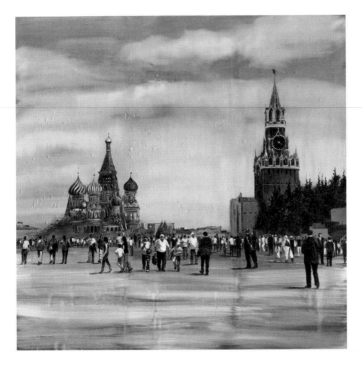

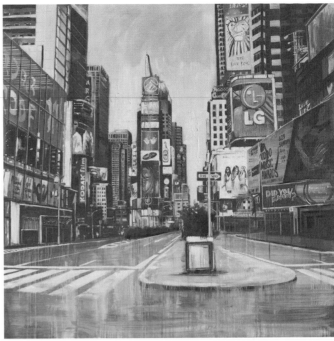

Moscú (Moscow), from the series Vacío (Void), 2012
Oil on canvas, 6 ft. 6¾ in. × 6 ft. 6¾ in. (2 × 2 m)
Consejo Nacional de las Artes Plásticas (CNAP), Havana.

Nueva York (New York), from the series Vacío (Void), 2012
Oil on canvas, 6 ft. 6¾ in. × 6 ft. 6¾ in. (2 × 2 m)
Consejo Nacional de las Artes Plásticas (CNAP), Havana.

Tokío (Tokyo), from the series Vacío (Void), 2012
Oil on canvas, 6 ft. 6¾ in. × 6 ft. 6¾ in. (2 × 2m)
Consejo Nacional de las Artes Plásticas (CNAP), Havana.

Tokío (Tokyo), from the series Vacío (Void), 2012
Oil on canvas, 6 ft. 6¾ in. × 6 ft. 6¾ in. (2 × 2 m)
Consejo Nacional de las Artes Plásticas (CNAP), Havana.

ALEJANDRO
CAMPINS

I received my training as a painter and started to study art history in Holguin, obtaining my diploma from the academy there in 2000. I then entered the ISA in 2004. Studying at the ISA is different. The courses are more conceptual. One has to justify one's work, back up one's research, develop artistic propositions. The goal of the ISA was to orient us more toward research, and especially to urge us to express what interested us most. In my case that was painting, contemporary art in particular. The ISA was helpful in that sense, enabling me to study the language of painting, its history, and more. I left the ISA in 2009.

When I talk about my work, to get people to understand it I always approach it from a formal angle. My work focuses on painting, drawing, and photography. Those are the three idioms in which I work. Basically, as an artist, I feel I'm an interpreter of three-dimensionality. Painting, drawing, and photography are three languages that reinterpret, interpret, or translate three dimensions into two. This has been a very important theme throughout the history of art. How does one translate 3D into 2D? How do you create other realities, a new image? Little by little my work has been pared down in this respect, and I've forged a kind of working method by which, depending on the subject I'm painting, I start by exploring the field and producing drawings and photographs. I use real film because it requires a whole process, from lab development to printing out. I make drawings and then I go off to the studio to paint.

For the last couple of years I've been working on a series depicting the amphitheaters and stages

**Born in 1981 in Manzanillo.
Lives and works in Havana.**

Manzanillo

Alejandro Campins's studio.

built in the 1960s and 1970s in every village in Cuba, to host cultural events and political demonstrations. Today, many of them are abandoned. I traveled all over the country researching them; I took a lot of photographs and then I produced a series of paintings about these places.

What interests me is the idea of the impermanence of things. We live constantly with the idea that what we do—that reality, including ourselves—is eternal and that we are supreme. In my work I try to speak about the impermanence of ideology, of concepts of reality, and about how it manifests itself in a landscape or a town.

I also like nondescript places, as if they were a result of a process of deterioration, frustration, or closure. I'm interested in the end of things—not in death per se, but death as a beginning, the possibility of a new phase. This is what intrigues me about this body of work: the fact that it looks timeless and that it's hard to locate in the past, present, or future. It's

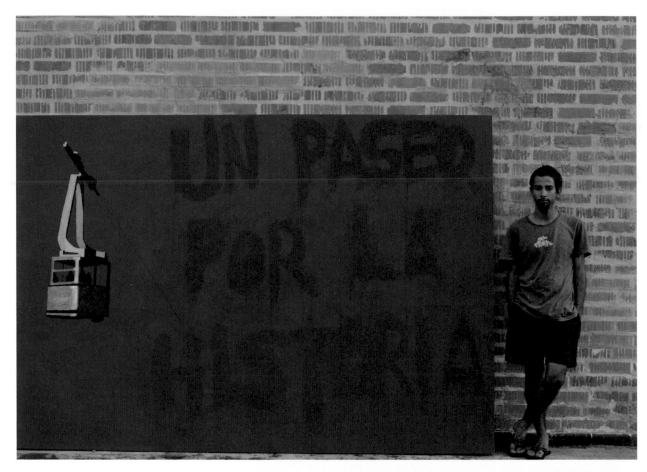

Alejandro Campins
in his studio with
the piece *Un paseo
por la historia*
(*A Walk for
History*), 2008.

Alejandro
Campins's studio.

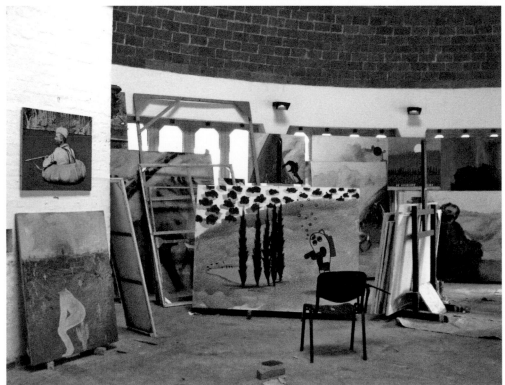

like playing with the temporality of things. I search for places that can give voice to this phenomenon. For example, I'll soon be traveling through several cities in Europe, taking photographs of places where bunkers were built during the Cold War and the Second World War. Today these sites are abandoned. I want to focus on them and see what I can say about them.

My work centers chiefly on landscape. Everything I have to say, I say it through the medium of landscape. For me, nature, and the relationship between architecture, nature, and humankind, are crucial. I produce large landscapes, but also small ones. The colors are important: I use neutral colors that are not typically Cuban. I also like these places to have a metaphysical, anonymous appearance. It's like stripping the landscape of its identity.

I enjoy talking about nature and about my relationship with nature. My work is very much inspired by and highly dependent on my obsession with travel, my desire to get to know new, unfamiliar landscapes. That's important for me. Nature is like a vast museum, which, from whatever angle one views it, tells stories full of life, death, and energy, about the old, about the new. Nature is constantly revealing things to us. ▬

Alejandro Campins's studio.

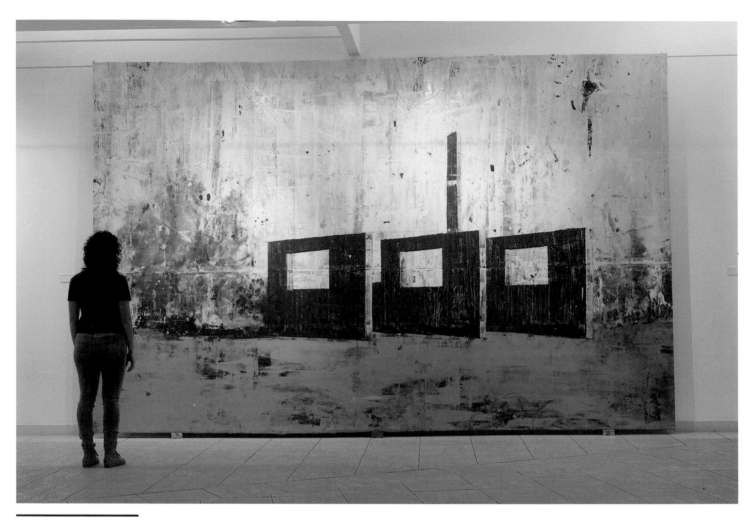

La Vigía II (***The Lookout II***), **2013**
Varnish on canvas,
9 ft. 10⅛ in. × 16 ft. 4⅞ in. (3 × 5 m)
Museo Nacional de Bellas Artes, Havana.

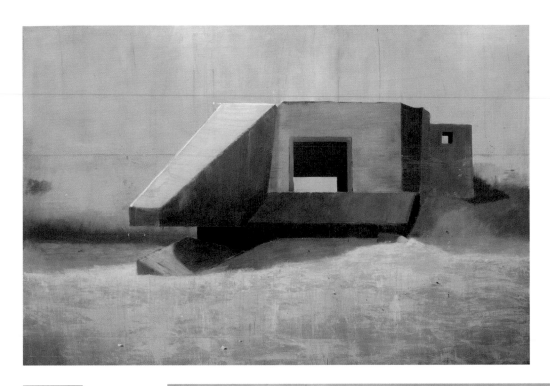

**Carruaje II
(Carriage II), 2018**
Oil on canvas,
8 ft. 5⅛ in. × 12 ft. 9½ in.
(2.57 × 3.9 m)
Private collection.

**Desayuno en la orilla
(Breakfast on the
Shore), 2014**
Oil on canvas,
5 ft 3 in. × 7 ft. 6½ in.
(1.6 × 2.3 m)
Sean Kelly Collection,
New York.

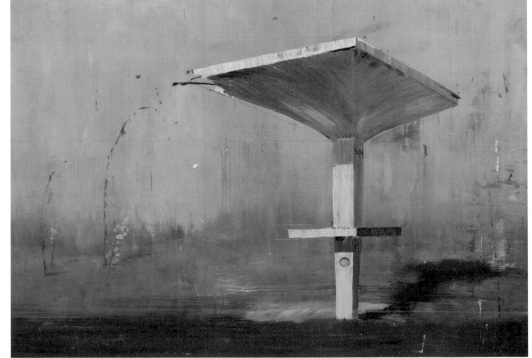

IVÁN
CAPOTE

Since 2001, my work has been based around sculpture and movement powered by electric motors. The influence of kinetic culture is easy to see. I also developed an oeuvre clearly shaped by the conceptual art of the 1960s and by minimalism, with its use of text, words, visual poetry, and the relationship between philosophy and poetry, though I later returned to kinetic art. At the present time I'd say my work is a mixture of painting, drawing, sculpture, and kinetic sculpture.

Since I started to employ philosophy in my research, the concept of the lie as a necessity that allows truth to exist has become crucial to me. When I use the term "lie" here, I'm referring primarily to the lie as a theme essential to—or inseparable from—art. As a poet once said (I think he was French, I don't remember his name): "Poets are liars who always tell the truth, their truth." That's how lying could be regarded as a strategy for saying things poetically. There are many kinds of lie: the harmful lie, the one that serves to disparage someone else or to divert them from the truth. But there are white lies, too: leaving things out, so as not to hurt someone; letting things go unsaid. That's the case with poetry, too, and with literary tools such as metaphor, which add a touch of poetry, slip a bit of suspense into a narrative, keep the reader guessing. One speaks the truth under one's breath. In my work I try to explore the concept of the lie in this sense, and not simply formulate a critique of people who lie. In my picture *Lies in a Glass of Water*, this is the meaning I wanted to convey. The lie is cleansed in water. By not speaking the truth, you preserve, you conserve. It becomes a necessity. —

**Born in 1973 in Pinar del Río.
Lives and works in Havana.**

Pinar del Río

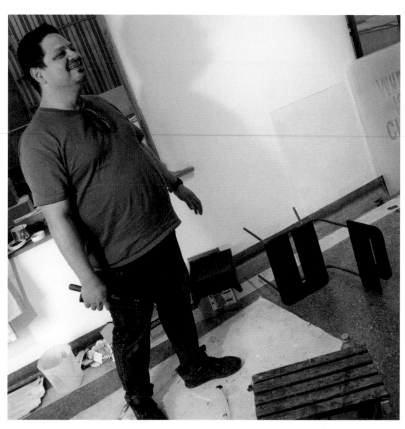

───────

Iván Capote in his studio.

───

Up, 2016
Steel and neoprene, variable dimensions
Collection of the artist.

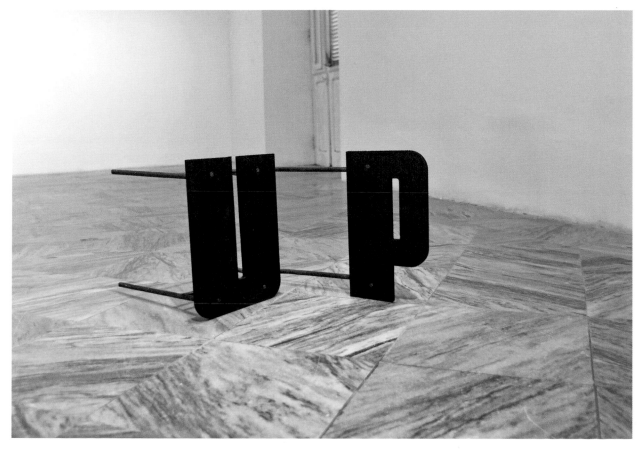

Iván Capote in his studio with
the works *Dislexia* (*Dyslexia*),
2003–16, and *Cifra* (*Figure*),
2016.

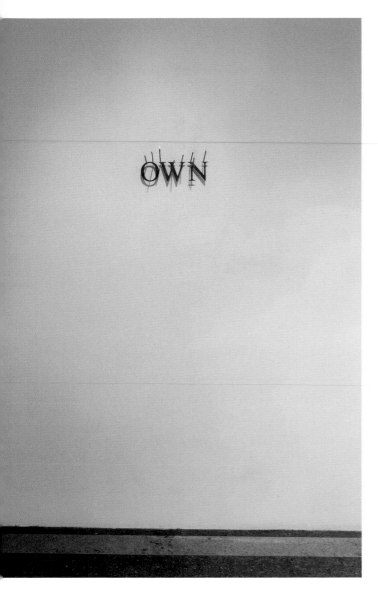

My Own, 2014
Steel, variable dimensions
Collection of the artist.

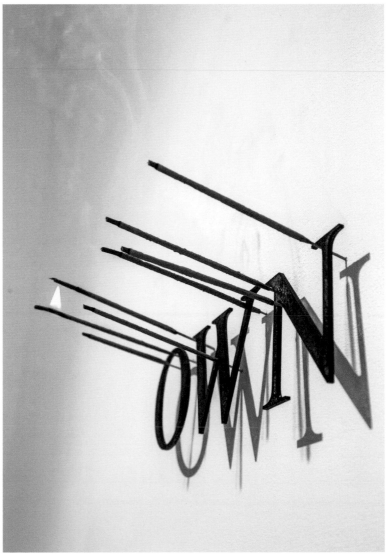

Over and Over, 2015
Bronze, variable dimensions
Collection of the artist.

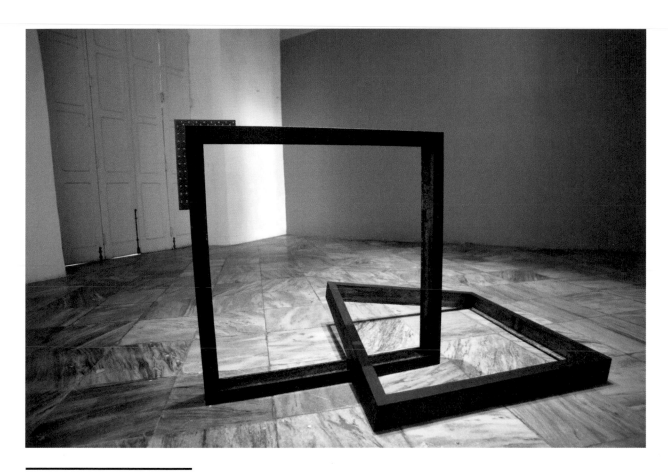

Verdadero y falso (*True and False*), 2016
Steel, variable dimensions
Private collection.

DAGOBERTO RODRÍGUEZ SÁNCHEZ
MARCO ANTONIO CASTILLO VALDÉS
LOS CARPINTEROS

We work in tandem. Our collaboration is above all a conversation. It's a constant dialogue. The artworks are more or less the result of this conversation. Sometimes, the conversation starts with a dream. Our exchanges play a great role in our psychology, in our relationship, and the result must always be a work of art. When we start our pieces, we're like workmen bringing our conversations into being.

In this sense, our oeuvre, and our drawings especially, are like a scratch pad. They've always been analogue, these means of communication. All these drawings are a way of beginning a conversation on art, aesthetics, or philosophy. Even if we do not phrase it this way, our conversations are very down-to-earth; we might even be quarreling. There's always a point of view, a discussion: that's fundamental. It is like a pair of oxen: when there's only one, it just doesn't work—you need two.

Cuba provides the backdrop to our work, even when we're in Spain or Indonesia. It represents a homecoming to Cuba, even if we're somewhere else. Physically, we always go back to Cuba, and when we're there, it's the same. Cuba is the theater that stages our work.

Of course, when we spend a lot of time in a country, that country begins to exert an influence. We've devoted many works to Spain—or, rather, the works have been affected by the situation there. We started to live in Spain when both of us had a reason to leave our homeland. We hit forty years old and said to ourselves, "We've never lived in Europe." We just had to spend some time

Caibarién

Camagüey

Dagoberto Rodríguez Sanchez, born in 1969 in Caibarién.
Marco Antonio Castillo Valdés, born in 1971 in Camagüey.
Live and work in Havana and Madrid.

in Europe. We did what we'd always wanted to do and got a studio together. In contemporary art, being based in one place is less important than it used to be: thanks to social networks and interconnectivity, you no longer have to stay in one place to work. It's a phenomenon that affected us when we were already comparatively old as artists. In any event, our work has more to do with material questions, with the physical world, with artificial objects manufactured by humans, and we can create it in lots of places. We're not anchored to any specific location.

Artists often have their own language: you know what you're going to talk about and how you'll say it. We have chosen to manufacture, and in manufacturing something we're making a statement; choosing a theme, a typology, a design, a structure. We think about craftsmanship involved in making a work: that's how we get our idea over. We reveal a number of layers that might be political or social through the way we decorate a space, make a piece of furniture, or invite someone to sit down in a certain way. It's these little themes that make up our oeuvre.

Up to a point, all our pieces are autobiographical. We grew up with next to nothing, and that's why we've always felt a special sensibility for—and a keen curiosity toward— physical objects.

We're always interested in how objects are able to translate feelings or frustrations. Which objects spark division or disappointment? Separation, happiness, nostalgia? What does such-and-such an object represent in the

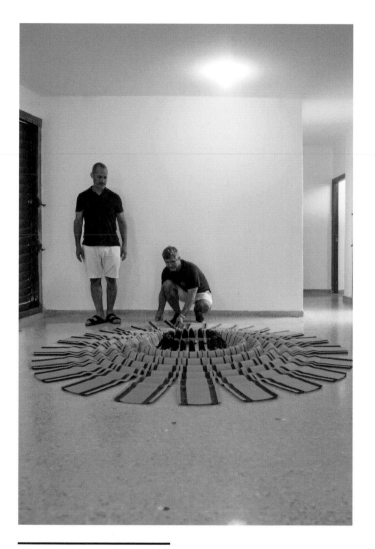

Los Carpinteros in their studio setting up the work *Patas de Rana (Frogs' Legs)*, 2010.

context of our lives and where we were brought up? Think about it a little. It's hard. How can you represent these questions through objects?

In a visual arts context, our work verges on craft. People have a problem coming to terms with our work because sometimes there is an artisanal element in the way it's put together or in the way it looks; but in our case, this artisanal feeling has a different starting point—an absence that occurred at a particular moment. ▬

Los Carpinteros was a group of artists established in the early 1990s. Its members included Alexandre Arrechea, Marco Antonio Castillo Valdés, and Dagoberto Rodríguez Sánchez. Arrechea left the group in 2003 to work in New York, and in August 2018 the two remaining artists decided to disband and to pursue their careers separately.

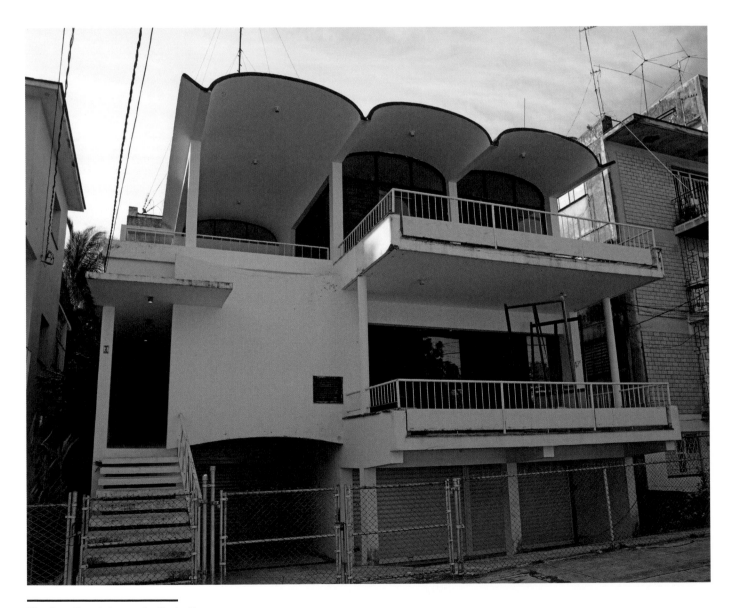

The Los Carpinteros studio in Havana.

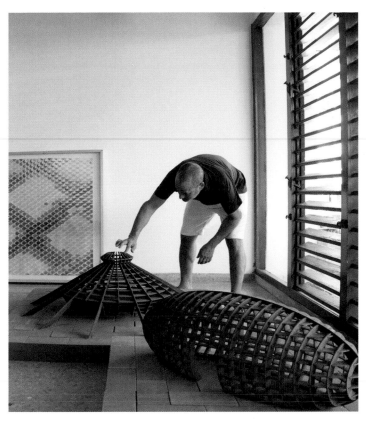

Los Carpinteros in their studio with the works *Sala de Lectura Coppelia* and *Sala de Lectura Baguette* (2013), and *PCC II* (2016).

Los Carpinteros in their studio.

Los Carpinteros in their studio.

ELIZABET
CERVIÑO

I approach the way I create art through spirituality: through the spirituality of my culture, my family, and nature.

When I create, the most important element for me is the idea. So, although I'm a painter, I also do performances and installations. I spend a lot of time doing research, testing out new materials. I study them for a year or two, and only then do I produce anything. I make many series in parallel, all of which result from this search for the right materiality. I believe that the material has something to say, that it conveys an idea. My output is diverse but highly unified; there's a constant unifying essence.

I put great store by the "threefold" nature of my work. For me, a work represents a combination of the original concept, the object produced or the material in which it is made, and the viewer. It's at that stage that I consider it finished. Object, idea, and viewer. One is nothing without the others. A clear idea does not exist if there's no object or if the viewer is not there.

My principal goal is not that viewers understand my work. My hope, above all, is that they look at it, that it creates a dialogue between them and it, so that a piece acts as a springboard for a mutual experience. What I'm looking for might be compared to the effect of a *haiku*: with its very brief, very precise three lines, the *haiku* can produce something like a mental fracture, a rational break in human thought.

**Born in 1986 in Manzanillo.
Lives and works in Havana.**

Manzanillo

That's what interests me, and not that viewers read the work intellectually. I want them, when faced with a piece, to experience a shock.

Other artists may feel the need to create more didactic works that talk about something. In my case, I want to see what the work says to you; I'm more interested in the communication that takes place, what you feel at that moment. What I want is for people to come to grips with the work, with a truth. It has to show a truth; it can't be anything false or an unreal thing. The world is already very unreal, very false. I try to be utterly sincere. I look to nature, trying to convey a certain minimalism in all my works. If I say "minimal," it's because very small things, a gesture, a movement, can become large-scale work or sculpture. Actually, what matters to me is focusing on this little thing, conjuring it up, glorifying it. Nature is composed of many tiny things. —

Elizabet Cerviño's studio.

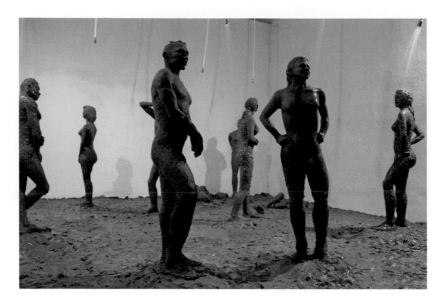

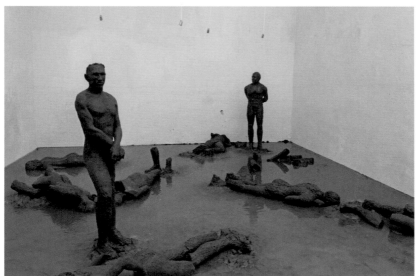

Fango (Mud), 2012
Baked clay sculptures
degraded by rain, life-size
Temporary installation.

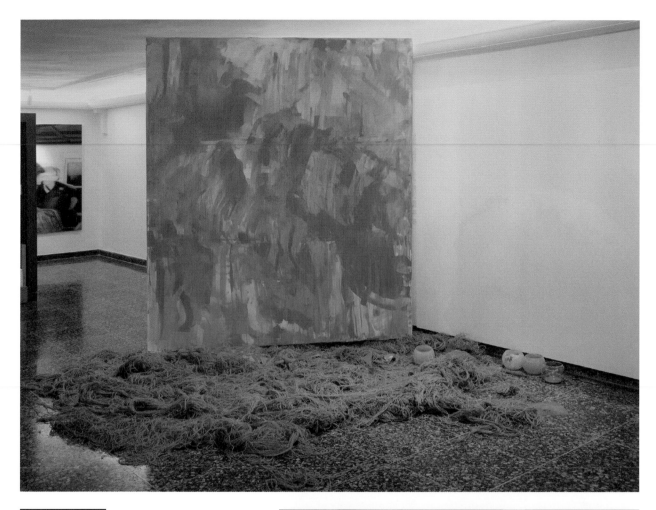

**Limpiar el fuego (Cleanse
the Fire), 2015**
Oil on canvas, burlap, wood;
canvas 7 ft. 10½ in. × 6 ft. 6¾ in.
(2.4 × 2 m)
Cancio Collection.

ARIAMNA
CONTINO

I am a graduate of the San Alejandro school and I've been a teacher there since 2004. I grew up in an environment where art was very important. Both my parents are artists. All my father's friends were also artists: Fabelo, Choco…. Some were his colleagues, and others his students, such as Sandra Ramos and Abel Barroso. That definitely helped me. I grew up among the work of all these artists. Inevitably, that influenced my life, then my work.

All my work begins with paper. Paper lends itself to all sorts of metaphors. You start sketching on it. You write down your first ideas on it. The meanings that paper can convey are significant for my work. It's where my fondness for the material comes from, and my interest in it. Nonetheless, I don't consider myself to be an artist locked up in one particular type of art. I prefer to explore ideas and to develop them by pursuing different routes, using different materials. But paper has always been fundamental.

Every piece starts with an idea. For example, let's take the *Arsenal* series, the series with the guns, which I started in 2012 and which featured texts. I read articles on the Internet about murders on university campuses. I'm a rather fearful person, and these news items got me wondering. Starting with these stories, I began to work on the piece. It was then that I had the idea of representing the gun, the weapon, using paper, including related information underneath, and especially of making the piece look really attractive. This duality fascinates me. The image looks quite neutral at first glance, but when you read it you discover what it's about and you grasp a quite different sequence of elements and information.

Born in 1984 in Havana.
Lives and works in Havana.

Havana

Ariamna Contino in her studio.

In the case of *Club de Los 27*, a series I began when I was twenty-seven years old, I was struck by the fact that people who were so young—and who had done so many things in their lives—could die. I was interested in this metaphor. I went on to make portraits of a series of people who died at twenty-seven, outlining all the things they'd already done at such an early age. One of the characters who interested me the most, and whose portrait was the most layered, was the revolutionary Camilo Cienfuegos.

No artist's work develops in the same fashion. Each has their own process of study and evolves differently. When I read a text about an artist's oeuvre, I want the critic to be able, as it were, to describe his or her artistic process, something that we cannot see. ▬

Views of Ariamna Contino's studio.

Camilo Cienfuegos,
from the series *Club de Los 27* (*27 Club*), 2015
Hand-perforated paper,
23⅝ × 23⅝ in. (60 × 60 cm)
Private collection.

Untitled, from the series
***Relicario* (Relic), 2014**
Fabriano paper and dipped
gold leaf, 17¾ × 23⅝ in
(45 × 60 cm)
Private collection.

DUVIER
DEL DAGO
FERNÁNDEZ

My work is a process; it's a work in progress. When I was a student, I thought of issuing a manifesto: how to construct a discourse on what your oeuvre is. Galleries always require you to justify your oeuvre. That just isn't practical. It would be better to address how it's put together, and in what way it affects the viewer. Working on the work's physical context, on its ideal location, is of fundamental importance to me, even more than the concept.

I very quickly became interested in the limits of drawing, in its materiality, in the notions of space and time. I wanted people to be able to touch the drawings. I investigated different types of hologram that could be created using technology, but that wasn't enough for me. The largest hologram one could create measured three feet (one meter). Now life-size figures are technically possible, but when I started that was out of the question. I later focused on finding out how to create the same effect physically. And I thought of layers of nylon, drawn on and laid one over the other. The action of drawing itself is really important to me. I sought the most suitable means of turning my drawings into genuine installations. To make my pieces that feature threads, I employed a hologram technique. The temporary character of my works is crucial too. I use cotton thread, nylon, wooden boards, screws, neon lights. It's a method that may sound rather hi-tech, but, because of the dearth

**Born in 1976 in Zulueta.
Lives and works in Havana.**

Zulueta

of materials in Cuba, it's more like handicraft.
I have to constantly reinvent my techniques to
compensate for these shortages. In the end,
that's perhaps what makes me a "Cuban" artist:
continual inventiveness. ▬

**Duvier del Dago Fernández
in his studio.**

Duvier del Dago Fernández
in front of his work *La guerra
de todo el pueblo* (*The War
of All the People*), 2007.

Untitled, from the series
La Historia es de quien la
cuenta I (History Belongs to
Those Who Tell It I), 2014–15
Ink and watercolor on cardboard,
3 ft. 3⅜ in. × 2 ft. 3½ in.
(100 × 70 cm)
Consejo Nacional de las Artes
Plásticas (CNAP), Havana.

Untitled, from the series
La Historia es de quien la
cuenta I (History Belongs to
Those Who Tell It I), 2014–15
Ink and watercolor on cardboard,
3 ft. 3⅜ in. × 2 ft. 3½ in.
(100 × 70 cm)
Private collection.

**Duvier del Dago Fernández
in his studio.**

JUAN ROBERTO
DIAGO DURRUTHY

**Born in 1971 in Havana.
Lives and works in Havana.**

Havana

Art doesn't have just one role. It all depends on the artist, on his or her inner self. There are those who don't see social problems and who aren't interested in them. There are those with a more intimate, more personal world. They don't take part in events. Then there are others, like me, who are more engaged in collective action. In my case, it's racism that prompts me to act; it has been one of the evils of humanity for a long time, but unfortunately racism is a virus that has mutated and taken on new forms. Violence and discrimination against women also continue. We don't confront the same problems with just one solution. That's why I believe there's not one view of art, but many.

For a while now I've been interpreting a certain history and heritage: that of the black man and his time as a slave. I've examined the period that followed slavery too, which we're living though now, where there's a lot of racial tension, not only in the United States or in Cuba. Almost everywhere there are twenty-first-century problems on a global scale.

I try to direct my art so that specific audiences—and sometimes the general public as a whole—can be made aware of a phenomenon. Many people don't want to square up to the problem of racial inequality. Others work to improve gender inequality. In my case, however, I concentrate on racial issues because they affect me directly. That's the credo I've always tried to follow.

I live this way and I believe I'll die this way, too. An art of struggle, I'd call it … others call it cultural *cimarronaje*. It's a way of shouting, taking a stand against injustice, continuing to produce work so that subsequent generations might live in a better world. And yes, I believe it's possible. ▬

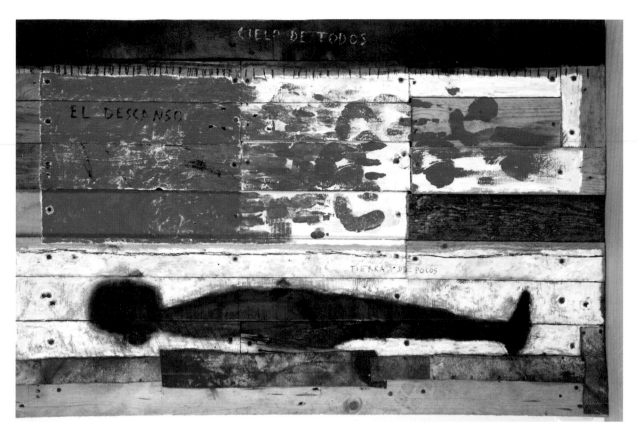

**Untitled, from the series *Un lugar
en el mundo* (*A Place in the World*), 2009**
Mixed technique on wood,
2 ft. 7½ in. × 3 ft. 11¼ in. (80 × 120 cm)
Private collection.

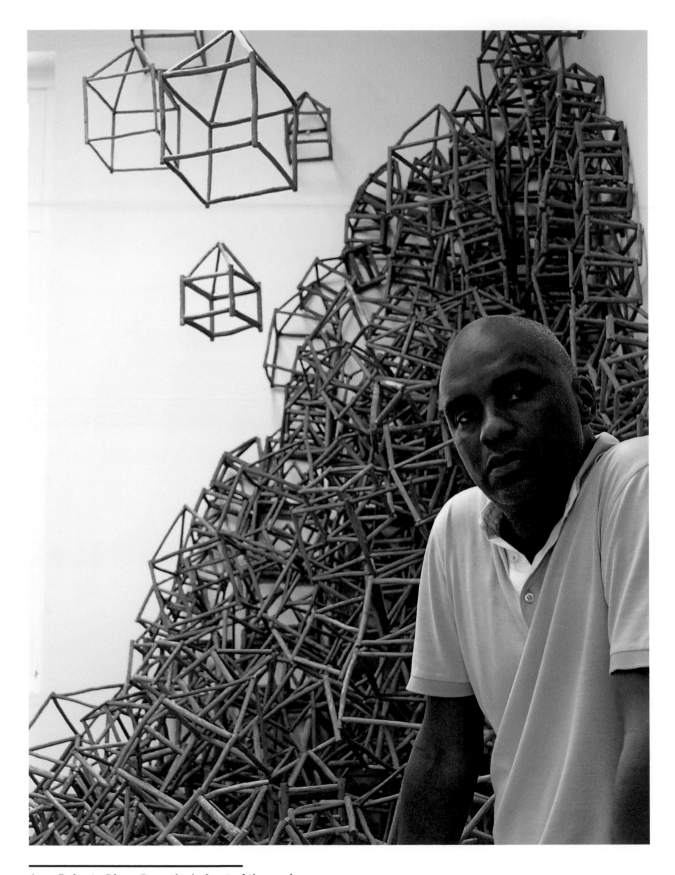

Juan Roberto Diago Durruthy in front of the work
Ciudad en Rojo (*Town in Red*, 2010).

**Untitled, from the series
La piel que habla (*The
Talking Skin*), 2014**
Mixed technique on canvas,
5 ft. 7 in. × 4 ft. 11 in.
(1.7 × 1.5 m)
Private collection.

**Untitled, from the series
La piel que habla (*The
Talking Skin*), 2014**
Mixed technique on canvas,
4 ft. 3¼ in. × 3 ft. 3⅜ in.
(1.3 × 1 m)
Private collection.

Maria, 2012
Mixed technique on canvas,
6 ft. 6¾ in. × 4 ft. 11 in.
(2 × 1.5 m)
Private collection.

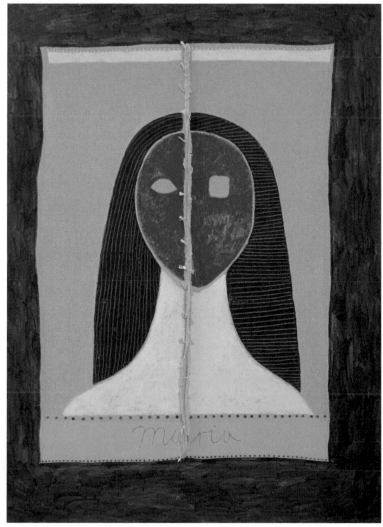

Untitled, from the series *Desde mi casa* (*From My House*), No. 3, 2003
Mixed technique on canvas, 2 ft. 7⅛ in. × 3 ft. 11¼ in. (79 × 120 cm)
Private collection.

Juan Roberto Diago Durruthy in his studio.

Untitled, from the series *Un lugar en el mundo*
(***A Place in the World***), 2009
Mixed technique on wood,
2 ft. 7½ in. × 3 ft. 11¼ in. (80 × 120 cm)
Private collection.

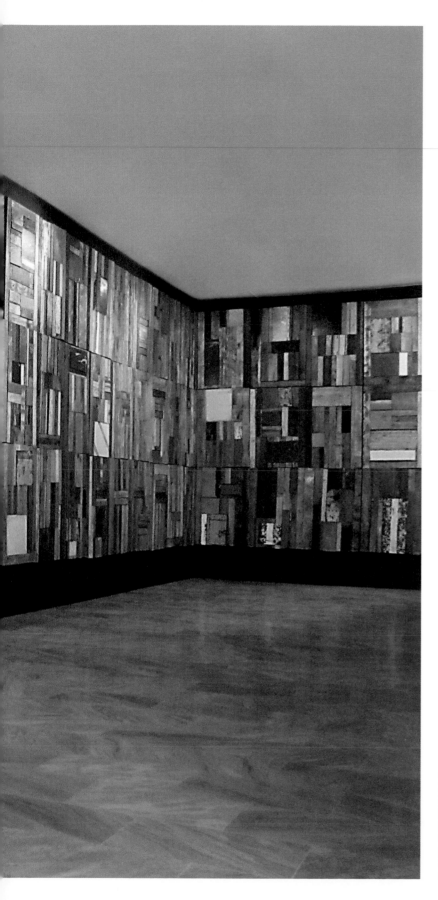

Untitled, from the series
El rostro de la verdad
(*The Face of Truth*), 2013
Mixed technique on wood, variable
dimensions
Private collection.
View of the installation
at the Wifredo Lam Center, Havana.

HUMBERTO
DÍAZ

Cuba's cultural background is changing. Artists are being presented with new avenues: private galleries, more amateur collectors, and also more knowledgeable collectors, philanthropists, and people interested in culture.

In my case it's a little different: I am in a line of work where experimentation can sell, but it requires a more audacious type of collector. One element of my works is fragility. I employ materials that can deteriorate. For me, this presents a challenge, but I'm also worried about the future of Cuba in this regard; right now there's a kind of vogue for Cuban art but— like all vogues—it will pass. The time will come when Cuba is no longer in the international spotlight, when much of what today is called "Cuban art" will lose its interest, and I'd like to be ready for this moment, so that my career outlives this period of intense focus. I'm concerned about the health of Cuban art. It could be affected negatively by several aspects of the art market, including commercialism. But, as always, the future is like an open door. That is positive, because there are many excellent artists and fine creators who will bring their own answers.

I produce large-scale installations, big interventions in spaces, but also small objects, performances, photographs, and videos. I try to search constantly for new experiments. At the moment I'm on the point of finishing a series of works relating to nature and to humankind.

I'm about to start a new cycle centered on the imperceptibility of art, or on gestures that, when they're large, they're invisible, but if they're small they're very easy to spot. These are little experiments I've just begun, but it seems that they offer a new approach in my work.

I am very interested in the relationship between human beings and nature. It can be harmonious or it can be aggressive. One can also be a victim of nature. Like any relationship, it has many levels, and I strive to explore all these layers and to find a balance. I'm fascinated by the idea of balance between humans and the natural world. Many of my pieces play with this concept of balance, of instability or being on the brink of instability, of resistance between objects. I believe that this highlights the tensions we have with nature, how we take from it and give to it, even if we do not always give it what's best. ▬

**Born in 1975 in Cienfuegos.
Lives and works in Havana.**

Cienfuegos

**Humberto Díaz
in his studio.**

La cigüeña (The Stork), 2016
Sculpture, branch, scythe,
10 ft. 2 in. × 3 ft. 7⅜ in. × 5⅞ in.
(310 × 110 × 15 cm)
Collection of the artist.

Stress Ball, 2017
Metal, 500 foam golf balls,
variable dimensions
Private collection, United States.

Facing page

**Humberto Díaz
in his studio.**

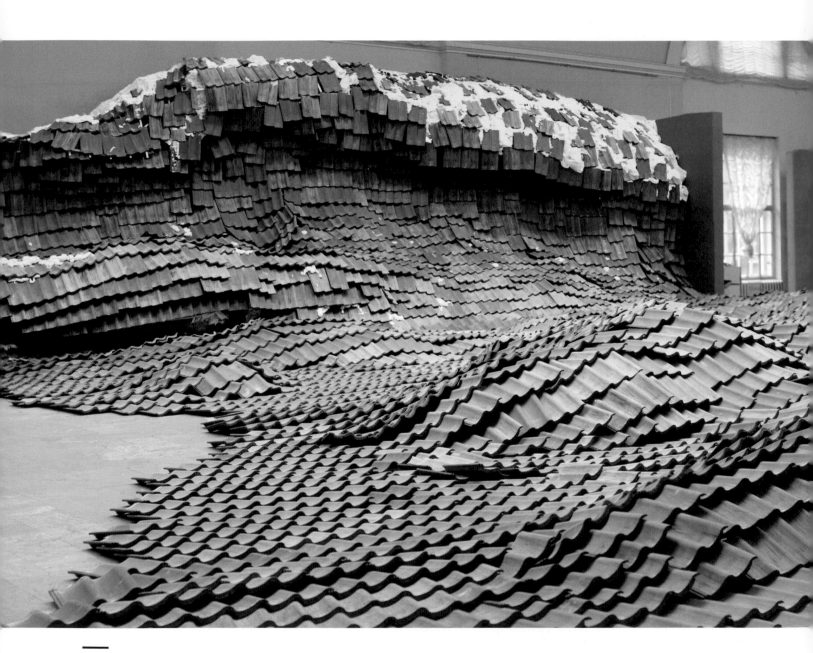

Tsunami, 2009
Ceramic tiles, plastic, cardboard, wood,
expanding foam,
7⅞ in. × 9½ in. × 17 ft. 8½ in.
(20 × 24 × 540 cm)
View of the installation at the
9th Biennial of Contemporary Art,
St. Petersburg, 2009.

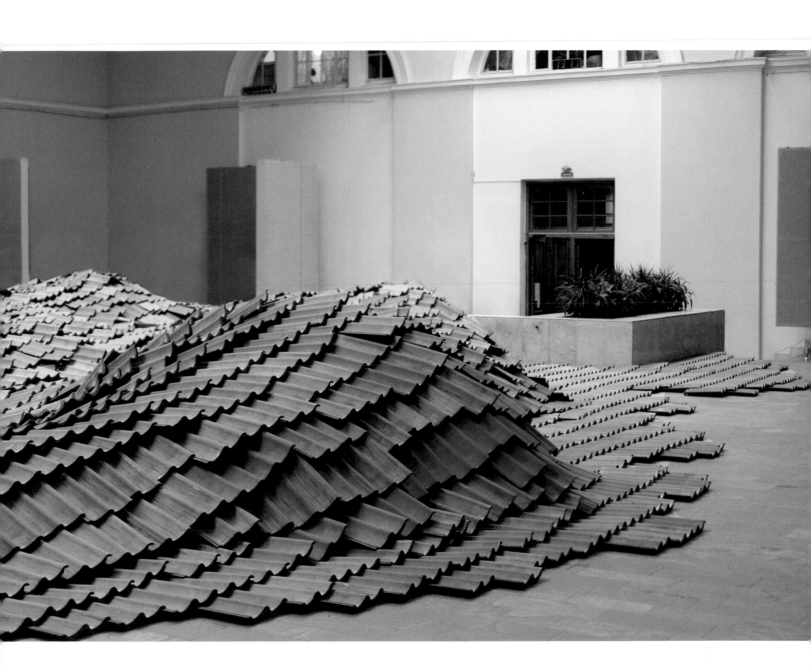

ROBERTO
FABELO

I think that, in my work, there's a "divergent" Fabelo, a "diverse" Fabelo, who remains the same, but who nonetheless feels obliged to show and to doubt his own work, to search and zigzag occasionally. That's because it's like a route, a journey that you follow, and by the side of the path, or below or above it, there are many things, many questions, many challenges, many attractions and enticements. And you continually swap from one side to the other.

Why do I do it? It's a question of curiosity. I'm very inquisitive, but afterward I tend to return to the main path, to Fabelo. I listen to a symphony or

**Born in 1951 in Camagüey.
Lives and works in Havana.**

Camagüey

read Borges, or try to analyze a Renaissance work or come up with a response to my own needs; it's always conditioned by time, but also by pleasure, by an inquisitiveness I don't plan for, because you can't preempt pleasure, emotion, or curiosity. You can be assailed by these emotions. You can be ambushed on your path; you can make your way prompted by curiosity, doubt, emotion, but you cannot plan for that. You can't say, "After the next two steps, I will feel emotional," or "After the next three steps, something will touch me." It's a continuous flow. And that's when I realize I'm very open and that my work is open too. Without a doubt the results of my work show the kind of register I operate in. That's why it's hard for me to stick a label on my work, to pigeonhole it. It's also perhaps the result of my experience of life, culture, and society, all that.

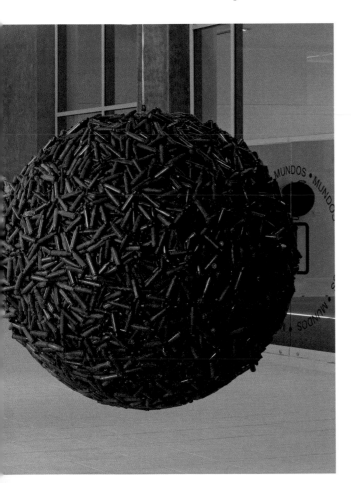

The essential Fabelo probably lies in the "graphomaniac" character I've always had; that frenzy for drawing, the desire to draw frantically, constantly, as if I were a child scribbling all over the place. I've followed this path since childhood, because, from infancy, that's what I wanted to do. And I have lost none of that curiosity, that restlessness. Forms, faces, animals, nature—all continue to intrigue me, and I've started dealing with the contemporary world a little too, well aware that I'm a bit incompetent on that score. Even though I think

Mundos (Worlds), 2005
Cartridge cases, nut kernels, vegetable charcoal, covered in aluminum, cockroaches, resin, fiberglass, iron, variable dimensions
Finsole S.P.A. Foundation, Italy.

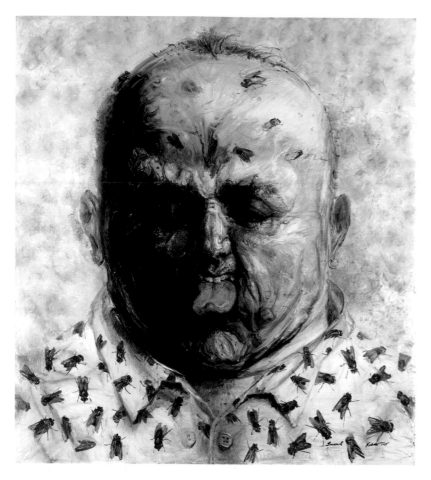

Gourmet, 2015
Oil on canvas, 7 ft. 6½ in. × 6 ft. 6¾ in.
(2.3 × 2 m)
Consejo Nacional de las Artes Plásticas
(CNAP), Havana.

that the search for new forms of knowledge is important, I sometimes feel I'm inadequate, because the search requires an energy, a physical and intellectual and emotional energy.

Sometimes what one has at one's disposal isn't enough, but I believe it's the right path. That's why I draw a lot, never stopping. And I examine my surroundings with heightened intentionality. That's the world I'm passionate about. I've been able to install a lasting curiosity and interest in my environment within myself, and I haven't ever really lost the thread or my capacity for amazement.

Even if I'd lived 500 years ago I would not have been very different. Humankind has characteristics similar to those we had back then. We continue to have emotions that govern all our plans. My essential condition remains that of a child in the countryside in Cuba, wide-eyed, who made little animals from his environment, out of wax from a honeycomb, or out of clay, or who tried to whittle a bit of wood. That persists in me.

Later, I taught myself to a certain extent, and I made efforts to broaden my knowledge; I've lived the experiences of an old man who'll soon be seventy. Everything is interrelated. This entanglement runs out through everything I do, in my drawings. I think it's almost miraculous. That's why I don't like talking about "stages," exactly, but about a permanent flow, because I've been interested since childhood in the forms that surround me. My inquisitiveness about living organisms, animals, people, plant life— it all forms part of my nature. It manifests itself in my liking for soft forms, in the pleasure I gain from the forms of nature, and also in the pleasure of thought. Thought itself is organic, as is obvious when it gives birth to forms of cultural or artistic expression.

I realize that I've always been a figurative artist, interested in shapes, animals, and in figures generally. Even if I am a figurative artist, I'm more attracted by abstraction, but I'm unable to work in the abstract. Occasionally, I discover an abstract significance in one of my pieces, but that's a question of concept, not form. I've sometimes found myself at odds with my standing as a draftsman, as a representative or interpreter of nature, but I've always gone back to it and given drawing its due place. It's as if I'd been deeply involved with a woman, but we drifted apart and then got back

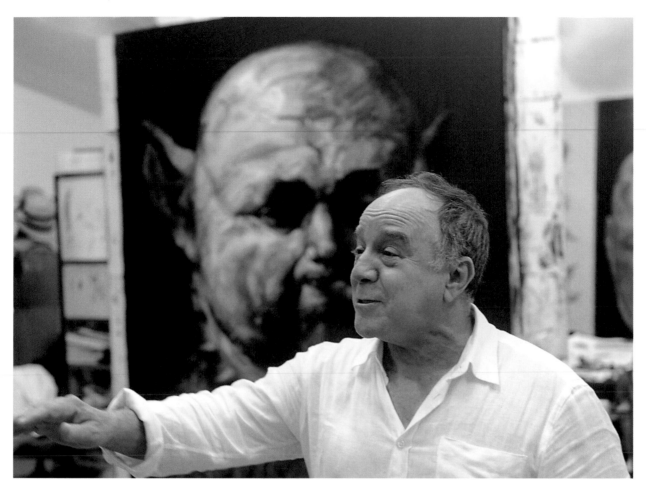

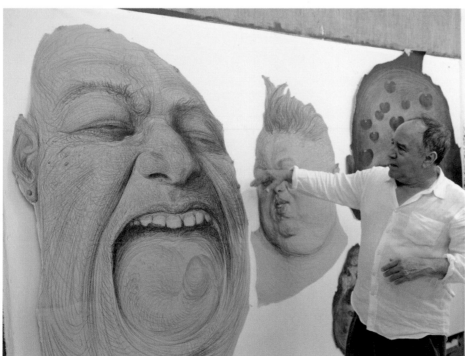

**Roberto Fabelo
in his studio.**

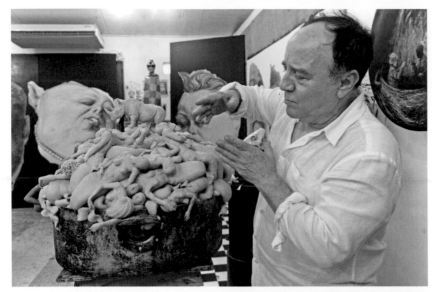

Left and facing page
———

**Roberto Fabelo
in his studio.**

—————————

Torres (*Towers*)**, 2005–18**
Iron, wood, aluminum, acrylic, silk,
animal skull, variable dimensions
View of the installation at the John F.
Kennedy Center for the Performing Arts,
Washington D.C. (2018).

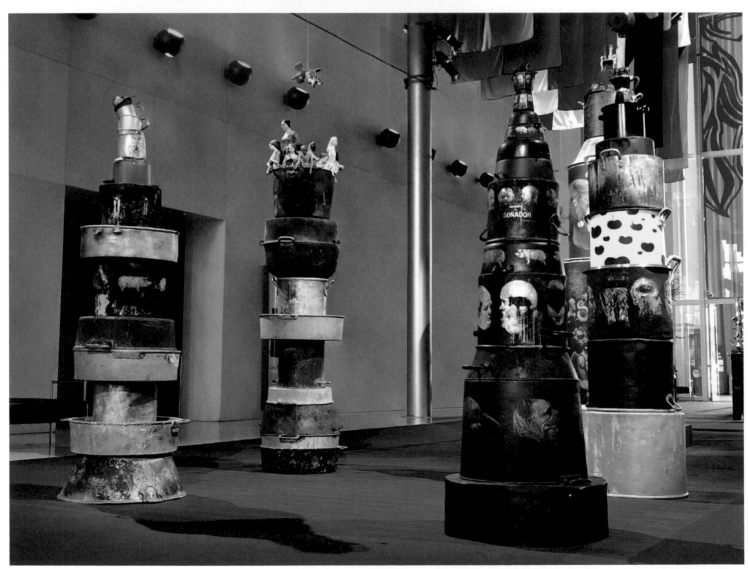

together again; I was happy once more, because we had discovered that we couldn't live without one another. Me, I cannot live without drawing.

For the most part I let myself be carried along by my pieces. I'm quite emotional … and an object conceived this way, an abstract object, can also be warm and moving and vibrant; it can possess just as much intensity or be just as representative. So emotion is not the privilege of just one artistic style. We all have this capability, just as desire and emotion belong to all, and no one can deprive you of them.

I draw, I paint, I manipulate objects, and some people respond to what I do. ▬

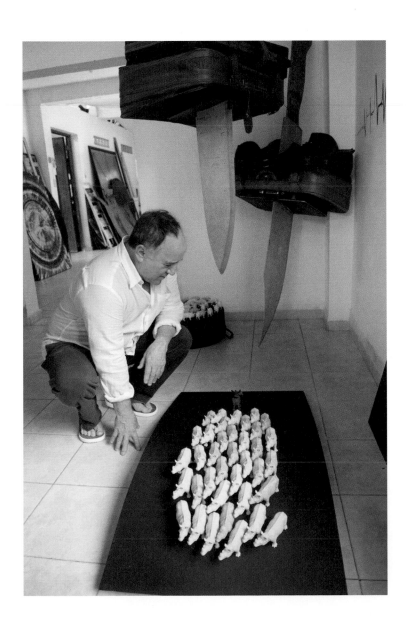

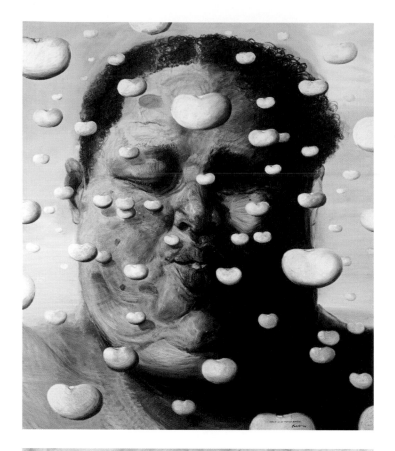

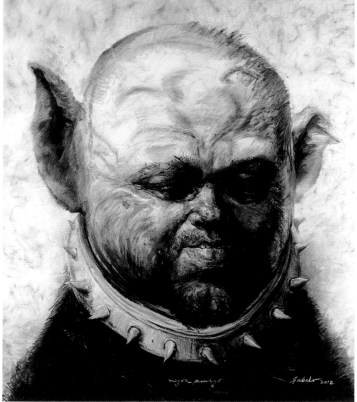

***Éxtasis de los frijoles blancos (Ecstasy of the White Beans)*, 2016**
Oil on canvas,
7 ft. 8½ in. × 6 ft. 8 in.
(2.35 × 2.03 m)
Collection of the artist.

***Mejor amigo (Best Friend)*, 2012**
Oil on canvas,
7 ft. 6½ in. × 6 ft. 6¾ in.
(2.3 × 2 m)
Collection of the artist.

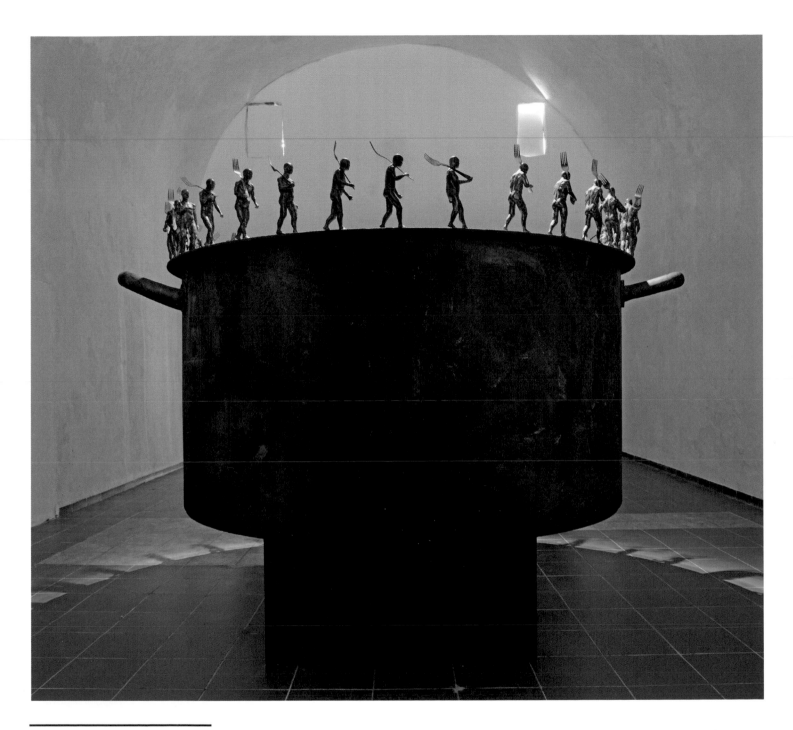

***Ronda infinita (Infinite Round Dance)*, 2015**
Iron cauldron with 33 bronze sculptures,
6 ft. 2¾ in. × 8 ft. 2⅜ in. (1.9 × 2.5 m)
Museo Nacional de Bellas Artes, Havana.

ADONIS
FLORES

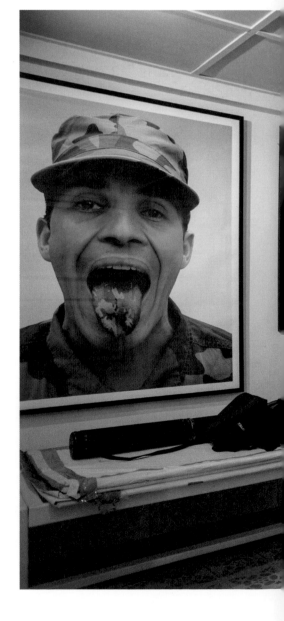

Most of my family comes from the world of culture. My mother studied with major national artists, and it's safe to say that, in a way, since my childhood I've had strong links to the visual arts. I used to go to exhibition openings in Sancti Spíritus, at the city's only gallery. My father had also studied history of art, and my sister was a musician.

What happened, though, was that I followed another path and went into the military. I studied at a military academy, Camilitos. From there, aged eighteen, I left for Angola. I did my military service in Angola and started out on a career in the services. From Angola I left for cadet school. Then I decided to take another approach, one perhaps closer to the art world, and made inroads into the world of architecture, which I also enjoyed. I received my architecture diploma, but in the end I decided to take a leap into the void, so to speak. That's the world of art: something completely undefined, uncertain. I started producing mature works in 1997, taking part in events and salons.

When I saw the Twin Towers tumbling down, that was a really tough day. I was already participating in artistic events. But when I saw what happened, I began work on the *Camouflages* series. This was work that looked at what I'd lived through in Angola, aged eighteen, where I'd almost been killed. In fact, I thought I was never going to get home. I really could have died out there.

Born in 1971 in Sancti Spíritus.
Lives and works in Havana.

Sancti Spíritus

94

When I saw the Twin Towers collapse I was really frightened, because Cuba was one of the countries in the "Axis of Evil." The threat of war hung over it. In the end it was Afghanistan that was targeted, but everything was under threat, and this fear gave me the strength to begin a work about soldiers: the *Camouflages* series. In a way, it was a means of relieving the stress. I was also very afraid because I was in the reserves and the idea of having to do another tour was very hard. That I might be going back to that life—I couldn't accept it. We were at war again, and Cuba was always a country in great peril. That's how it all started.

I also make installations: works that involve the object. It's like an imaginary game. For example, there's the series I call the *Death's-head*, there's another series, *Boots*, which generated many works, including one I think of as really important: *Platoon*. It's ball-shaped; it's like a cluster of twenty-one soldiers, exactly the number of soldiers in a Cuban platoon.

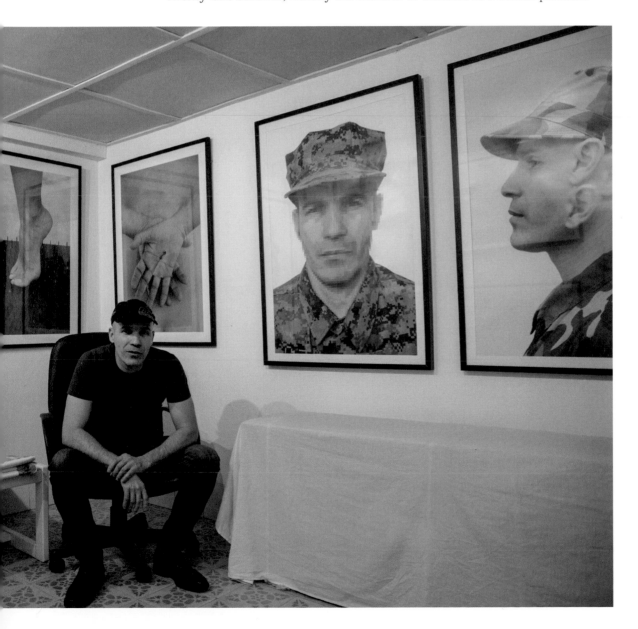

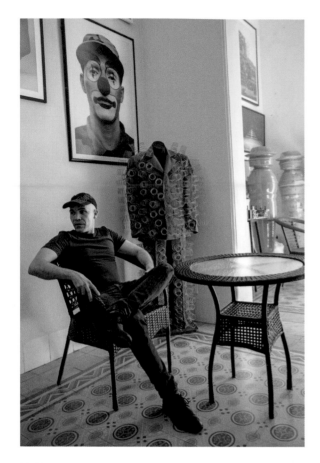

**Adonis Flores
in his studio.**

And they all are connected to a center, rolling about all over the place. It deals with the way war is conducted; war, and the people who take part in it, such as soldiers. Soldiers are sent anywhere and they don't question their orders. And sometimes this antagonizes the soldier, because he can't be ready to deal with something if he doesn't yet know what it will be.

Although the works are rather aggressive, and deal specifically with the theme of the military, I've tried to go further, to depict all the violence there is in the world. The military world is hard … it's a world in which you have to act without knowing whether you're doing so for the best or for the worst. The ideal would be if the army did not exist, that's what I think. And in fact there are countries that have almost no police. They are more developed societies. It seems to me that the evolution of humankind must result in the complete abolition of the army and of war, and in the acknowledgment that harmony is possible.

I work a lot with humor. It's essential to me if I want to understand this world without stressing out. If one works on dramatic themes producing

Adonis Flores's studio.

¡Descansen! (At Ease!), 2008
Digital print, 3 ft. 6½ in. × 2 ft. 6¼ in.
(108 × 77 cm)
Consejo Nacional de las Artes
Plásticas (CNAP), Havana.

dramatic work, it becomes tautological. It is more bearable when there's some humor. The message is conveyed more easily. Humor is crucial: a little irony creates a spark that wakes you up. Occasionally the spark combines drama with humor. This spark is important. I always see it when people look at my works and all of a sudden burst out laughing. They laugh, but intelligently, they analyze the essence of the work, and that's the key. What's really important is to affect people, to shake up their brain cells a bit.

In my view, it's a person's sensitivity that compels them to change their life and to look to improve humanity's lot. An artist must be receptive to the problems of humankind.

There can be a change in the thinking of every person who sees an artist's work. This change can definitely happen. What's needed is for those who have power over the masses to also see these works, because most people are unable to change things on their own. But starting at the bottom, with just one person—it's still an essential step. ■

Pelotón (Platoon), 2009–13
Resin, fiberglass, leather, laces, natural rubber,
diam. 5 ft. 3¾ in. (1.62 m)
Collection of the artist.

DIANA
FONSECA QUIÑONES

I like to play around with fiction, reality, perception, and deterioration.

My work is very reflective. My pieces draw on my everyday reality. I work with elements from my environment, with the things I can see. I walk about and look at the city. It inspires me constantly, everything I see, the people, the objects … An idea for a work can arise from a conversation with my son or from the sight of some old building. For me, the tumbledown buildings are like the skin of the city. I salvage a little of this skin; I recycle materials, I classify them. Then I do paintings that are like color studies; they're like a "happening" because I do them spontaneously. I have no preconceived idea of how they'll turn out. So each one is a unique piece, depending on the range of colors I have at my disposal. I never repeat a painting, and the way they're always different fascinates me. Creating them is such fun precisely because the results are always different. They surprise me; they're out of my control. What interests me is transforming a damaged object into something else, into art. This series is entitled *Degradation*. There's a parallel between the gradation of paint colors and the degradation inherent in our city's architecture, which is so beautiful, so dilapidated.

My work can't be pigeonholed, it's multifaceted. What I do is to subordinate the materials and the means to the idea. I make conceptual art. It's the contents that are

**Born in 1978 in Havana.
Lives and works in Havana.**

Havana

important. I then select whichever materials the idea brings to mind, using rather direct—though not literal—clues. There's always metaphor and poetry.

My work is very lyrical. It's also a little subversive sometimes, and usually existential, because I'm always talking about humankind, about our concerns. It seems to me that my oeuvre keeps step with my mental processes: in the act of thinking, I work things out, I reflect, I delve deeper, and the work goes deeper as well.

I enjoy playing with duality, with ambiguity, reality, and the virtual. That's why I like video art: I can transform something unreal into a reality; and that something is then accepted as a truth, because the medium of video is implicitly connected with the idea of veracity. ▬

**Diana Fonseca Quiñones
in her studio.**

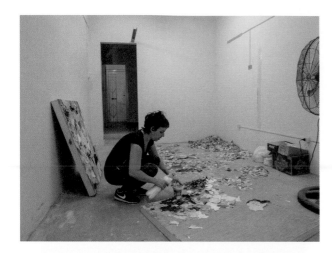

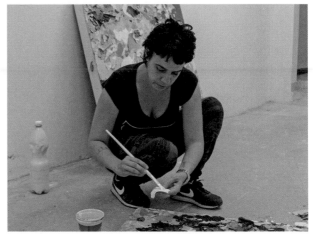

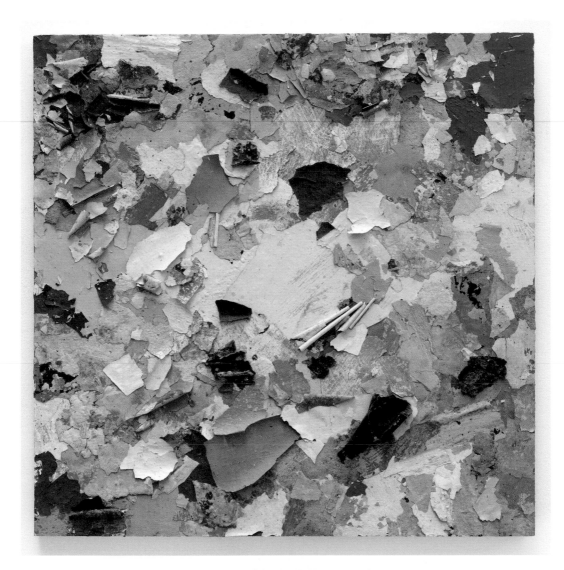

Untitled, from the series
Degradación (*Degradation*)
Paint fragments on wood,
3 ft. 3⅜ in. × 3 ft. 3⅜ in. (1 × 1 m)
Private collection.

Pasatiempo (*Pastime*), 2004
Video, 4 min. 45 sec.
Collection of the artist.

RENÉ
FRANCISCO RODRÍGUEZ

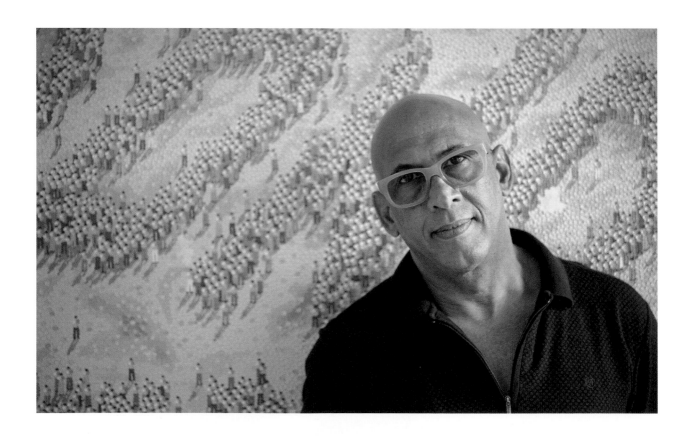

**Born in 1960 in Holguín.
Lives and works in Havana.**

Holguín

I come from the National School of Art, which was set up on a wave of utopian idealism. Cuban culture is founded on the concept of utopia, on the dream that the country must reach out to the whole cosmos through culture, music, and physical expression; and also through theater, dance, and the circus, a subject that was also taught at the school. This utopian philosophy was one of its extraordinary facets. Not only did I live through it as a student, I also experienced it during my years there as a teacher. In comparison, my own work is as insignificant as a grain of sand.

I think I've always tried to be exacting in terms of my work. I've always tried to be a demanding teacher. I'm used to being very friendly with the students, but students usually find me hard-going, because I think you have be quite strict. Sometimes you have to be tough, too, like a Chinese master who drums knowledge into you by hitting you on the head with a ruler.

I'm not wedded to just one thing. I'm constantly searching. I'm always trying to explore different paths. I want to try things out. To my mind, creativity is a kind of endless adventure. I don't like the idea of becoming a world-famous artist, an artistic "pope." I like being a researcher, a person burdened with mistakes. I think creativity is founded on the errors and discoveries you make, and on what you abandon; from a practical point of view, I think that's

René Francisco Rodríguez in his studio.

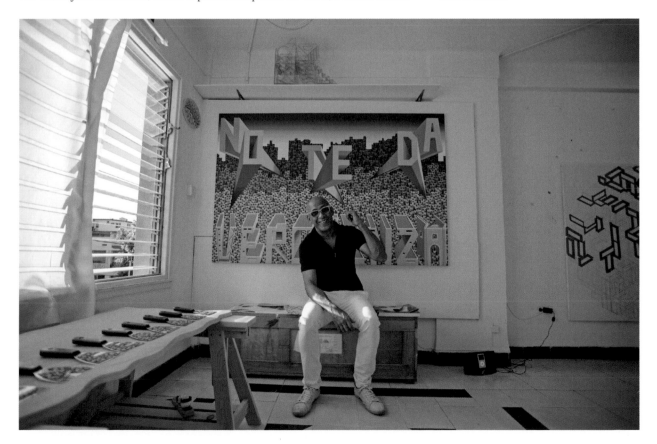

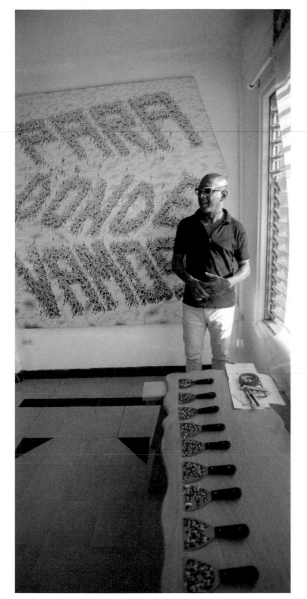

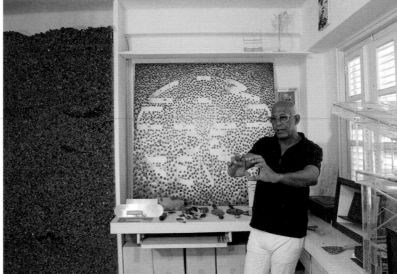

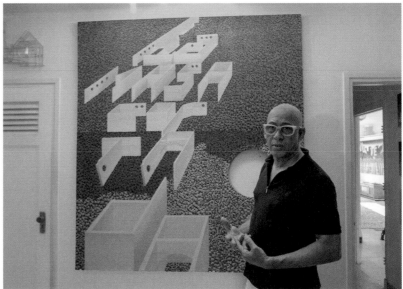

**René Francisco Rodríguez
in his studio.**

Facing page

*Fábrica de utopias
(Utopia Factory)*, **2006**
Oil on canvas, 28¼ × 18¾ in.
(71.8 × 47.6 cm)
Private collection.

pretty positive. I've been lucky enough to be able to always show my work in Cuba and to have an audience. It's always gratifying that the public comes to exhibitions and that friends come and criticize. It's something that has been lost over time, but I'm still able to find friends who offer criticism, who laugh at something you've messed up, who draw your attention back to your art. ▬

Brotes (Buds), 2014
Oil on canvas, 5 ft. 3 in. × 6 ft. 6¾ in.
(1.6 × 2 m)
Collection of the artist.

Di la verdad (Tell the Truth), 2014
Oil on canvas, 3 ft. 11¼ in. × 3 ft. 11¼ in.
(1.2 × 1.2 m)
Collection of the artist.

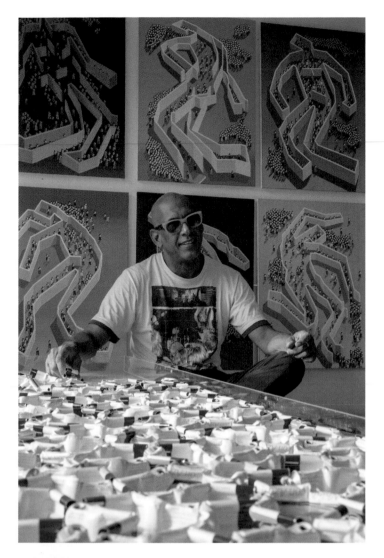

René Francisco Rodríguez
in his studio.

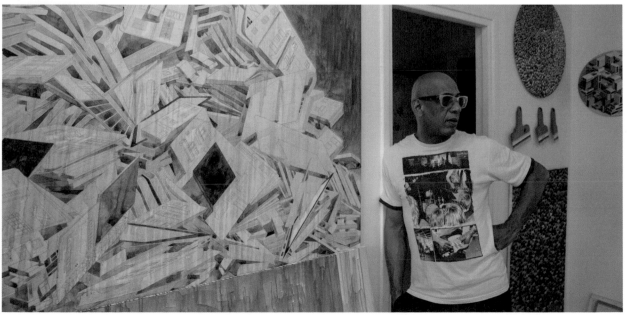

CARLOS
GARAICOA

In many respects, I'm self-taught. I'm a bit of an outsider. I never attended an art school, as either a child or a teenager. I did three years of military service, painting a lot during my spare time. After my service I was accepted at the ISA, where I spent five years.

In the 1990s, I became involved in a range of public events. I employed various disciplines, such as photography, photography combined with drawing, and installation, to set up a relationship with the city. The public space, and more precisely Havana, is the focus of my attention. I was brought up in the old city. It was my playground, which explains my relationship to its walls, to the dilapidated façades, and to the history of these historic buildings. I recycled fragments of the city, using them in objects and installations. I've become so interested in architecture that these days two architects work with me; sometimes I think I'm a town planner or an architect. The environment I create around my work is like a skin or a surface, but above all it's a way of talking about politics, about history, design, painting, and writing. What I really want to do is develop a multipurpose language of communication.

The question of immateriality is another focus of my activity. I've developed new techniques in photography, topology, and sculpture. I've produced designs using yarn and tapestries. Lately I've created models of cities out of various materials including thread, wax, glass, and paper.

Born in 1967 in Havana.
Lives and works in Havana and Madrid.

Havana

In my oeuvre I hope to highlight our relationship with the fragility of life, fragility with regard to the landscape. I always use a great deal of writing in my attempts to reveal reality.

I had the chance to spend a lot of time in New York. America was important in my work. It was there that my career took off, and it was from there, too, that I made trips to other places. It was during this period that cities really became the center of my output.

Over the last ten years I've exhibited in museums in Cuba and abroad. My work has been presented to new audiences, and recently I've held museum exhibitions in Italy, London, and Portugal. With experiences like that, it begins to dawn on you that to be an artist is universal, that being regarded simply as a Cuban artist is restrictive.

Over the last ten years I've tried to understand the places I've visited. For example, recently I was in Germany for a show in Munich.

Carlos Garaicoa in front of his piece
Foto-topografía, oficios y Santa Clara
(*Photo-topography, Trades,*
and St. Clare*), 2012.

I made works especially for a German public; that is to say, I deliberately used elements from their history. For me, as an artist, it's crucial to situate myself in a given context. Language is a fantastic thing if you learn to use it well. It makes it possible to widen your audience. But of course I know that my most receptive public is here in Cuba. They really follow and understand my work. ▬

Untitled, from the series
Nuevas arquitecturas
(*New Architecture*),
2003
76 rice-paper lanterns
NCTM e l'Arte Collection,
Milan
View of the installation
at the Wifredo Lam Center,
Havana.

**Carlos Garaicoa in his
studio with two of his
abstract photographs
taken in Angola in 1997.**

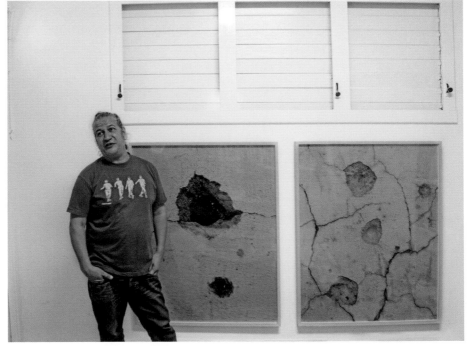

"Arcs" ("Arches"), from *Jardín japonés*
(*Japanese Garden*; detail of the
installation), 1997
Stone, wood, Japanese doors, text on color
photographs, and vinyl records, variable
dimensions
Collection of the artist.

Following double-page

***Project fragile* (*Fragile Project*), 2017**
Glass, magnets, Plexiglas, wood,
5 ft. 11¼ in. × 50 ft. 3⅛ in. × 23 ft. 1⅛ in.
(1.81 × 15.3 × 7.04 m)
View of the installation in the Galleria
Continua, Beijing.

Below

Carlos Garaicoa in front of his work
Untitled, Cocoon **(2015).**

ROCÍO
GARCÍA

I studied at art school. I then obtained a travel scholarship, going to study in Leningrad. By chance, my placement was in one of the most interesting and important academies in Europe: one that keeps faith with traditional teaching and remains uninfluenced by others.

I went back to Cuba to do my civilian service and thought I'd complete it in three years, but I liked it: I liked the relationship with the pupils and the atmosphere at San Alejandro, which in the end became my school. And so I've been offering courses here for twenty-five years. I could retire, but I've not thought about that yet.

I've always worked in series, and within each series what interests me is themes that patently relate to the human condition, to human beings and their psychological, sexual, and social conflicts, whether related to politics or not. To an extent one of the constants in my work is the concept of power in society, and how it can get the better of you sometimes and lead you down the wrong path. In a way, the issue is how those who have power manipulate you, and how you, when you have power, manipulate others. This is the world of human relationships. Sometimes we feel powerful within a sexual, social, psychological, political relationship, and we manipulate one another. We fall into the trap of human selfishness. I've addressed this question in various series, and they can have a very erotic aspect. I believe eroticism is integral to human beings, that everything is connected to the world of eroticism. Sometimes people think that eroticism relates solely to the sexual. But it can transcend psychological states and can affect your social attitude with regard to others. All that is part of what I'm saying too. ■

**Born in 1955 in Santa Clara.
Lives and works in Havana.**

Santa Clara

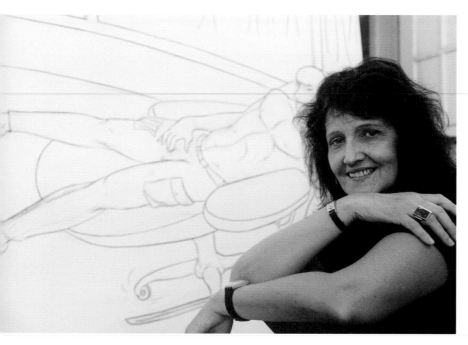

—
**Rocío García
in her studio.**

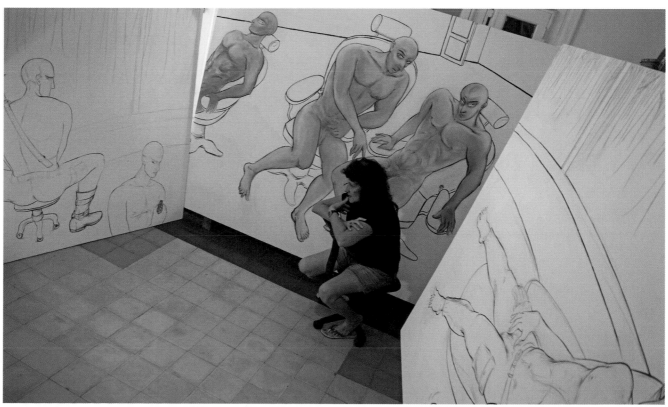

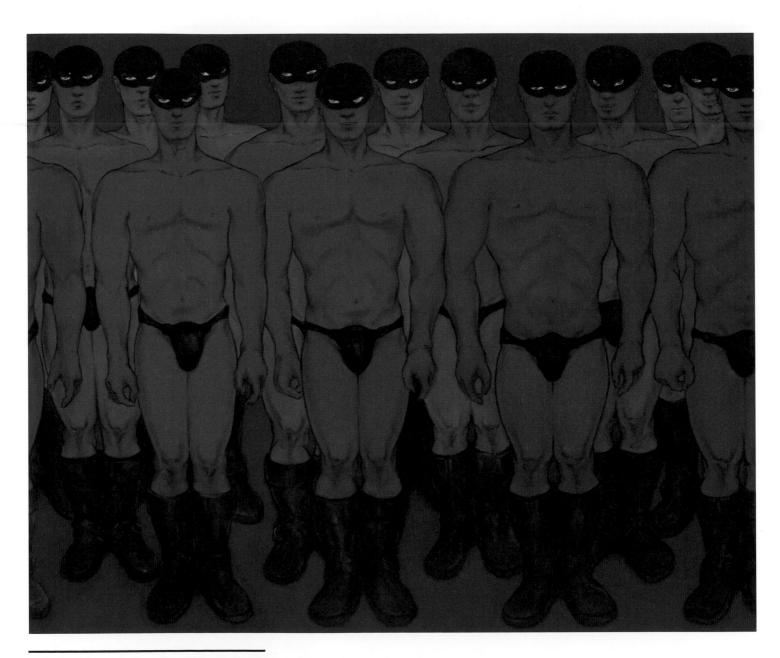

Pelotón (_Platoon_), from the series _El domador y otros_
cuentos (_The Tamer and Other Stories_), 2003
Oil on canvas, 5 ft. 3 in. × 6 ft. 2¾ in. (1.6 × 1.9 m)
Private collection.

***El regreso (The Return)*, 2012**
Oil on canvas, 6 ft. 6¾ in. × 7 ft. 6½ in. (2 × 2.3 m)
Collection of the artist.

**Rocío García with one
of her works in progress.**

La nieve (*Snow*), **from the series
El thriller (*The Thriller*), 2006**
Oil on canvas, 6 ft. 6¾ in. × 7 ft. 6½ in.
(2 × 2.3 m)
Private collection.

Un ruidito ... (A Rustle...), **from the series**
El regreso de Jack el Castigador (*The Return
of Jack the Punisher*)**, 2012**
Oil on canvas, 5 ft. 3 in. × 6 ft. 2¾ in. (1.6 × 1.9 m)
Private collection.

Magia blanca (*White Magic*)**, from the series**
El regreso de Jack el Castigador (*The Return
of Jack the Punisher*)**, 2012**
Oil on canvas, 6 ft. 6¾ in. × 7 ft. 1⅛ in. (2 × 2.17 m)
Collection of the artist.

Un ruidito ... (A Rustle ...), **from the series**
El regreso de Jack el Castigador (*The Return
of Jack the Punisher*)**, 2012**
Oil on canvas, 4 ft. 7⅛ in. × 5 ft. 10⅞ in. (1.4 × 1.8 m)
Private collection.

LUIS GÓMEZ

I started my career very bound up in the work of artists who'd been my teachers: Juan Francisco Elso, José Bedia, and Ricardo Rodriguez Brey. My work was focused on anthropological discovery and had an anthropological standpoint. Later it evolved into something more ambiguous and more open, in which viewers could see one of my pieces and—this was my intention—perhaps feel a connection with different cultures. Religion was irrelevant. The point was to band together, to seek out points where different cultures coincided.

Then I started to become more interested in new technologies, and I suppose this allowed me to consider myself from a distance and to rethink the milieu of art. I became fascinated by the question of how art functions, and how there are micro-powers that direct the art world. These micro-powers then grow into a kind of mafia organization that then decides what is and what is not art. In the end I was intrigued by how these circles of power defined art.

Even if my work might occasionally contain a political or a social message, its significance is more cultural. It tries to show how we function today, for good or for evil. I do not provide value judgements, but I try to reveal what we are. ▬

**Born in 1968 in Havana.
Lives and works in Havana.**

Havana

**Untitled,
from the series
*La habitación
de Jules Verne
(Jules Verne's
Room)*, 2005**
Digital photograph,
25¾ × 35⅛ in.
(65.4 × 90 cm)
Private collection,
Spain.

Luis Gómez in his studio.

Untitled, from the series *La rivoluzione siamo noi* (*We Are the Revolution*), 2018
Acrylic on canvas, 2 ft. 1½ in. × 3 ft. 2½ in.
(65 × 98 cm)
Collection of the artist.

Gimme Shelter, 2017
Mixed technique, variable dimensions
View of the installation at the Diana Lowenstein
Gallery, Miami.

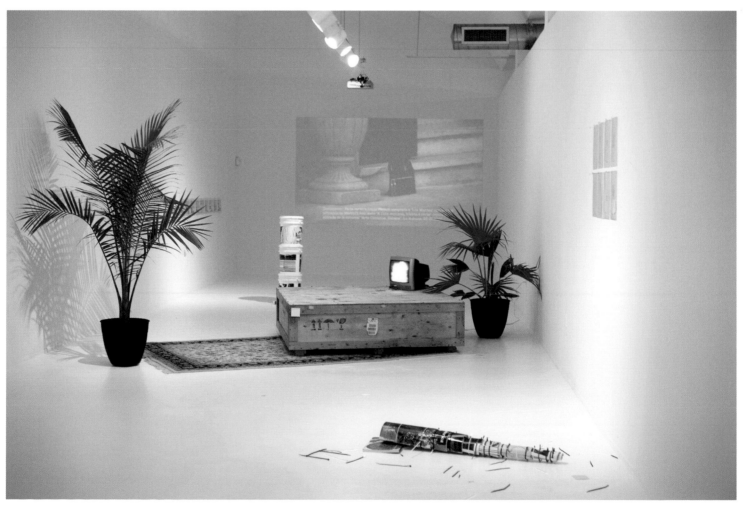

Ya nada nos pertenece (Nothing Belongs to Us Anymore), 1991
Leather, metal, and paint on wall
6 ft. 6¾ in. × 13 ft. 1½ in. (2 × 4 m)
Private collection, Italy.

GLENDA
LEÓN

M y work is a spiritual journey. It's a reflection of my inner, personal life—a trip during which I'm jettisoning the things I don't need. It's also a path to lightness, silence, honesty, purity.

It's very hard to explain an experience to someone who has never had that experience. It's like saying that strawberries have a particular taste but, if you've never tasted one, you really won't have any idea. The same with breathing in the sea air. I can tell you it smells of salt, but it's not quite like swimming in the sea. It's an experience, and for that reason it's difficult to write about what's behind it.

If I go down to the seabed and bring up something I experienced, I bring it up in the form of an image or a sound. We can talk about it, because it's something I bring forth into reality. That's why many of my works deal with silence and sound.

When I started out, I used to do lots of drawings of my hair, following its shape. It was like showing what's hidden. I also began to be interested in a taboo concept: beauty. I worked with real and artificial flowers as symbols of beauty. Most of all,

**Born in 1976 in Havana.
Lives and works in Havana and Madrid.**

Havana

however, it was music that appealed to me—
it was of fundamental importance. It acts like
a kind of direct connection between the soul,
the heart, and the body.

As a child, I did ballet. I wanted to be a
dancer. I even started a career as a dancer.
I wanted to be a choreographer and work in
theater. Then, one day, I realized that what
I was looking for was something visual; in
choreography I was searching above all for
images. And so I did performances, and then
ended up making installations where sound
played a major role.

At that time nobody was really interested in sound art. There
were artistic installations in the 1990s that featured sound, but the
sound did not play a pivotal role. I wasn't the first, but I was among
the earliest to be interested in video art as a tool.

People often say to me, "What you're doing isn't serious, it's
not art"—the same comments they made about my flowers. But
I carried on, and now I'm happy to see that my work has gained
national and international recognition. ▬

**Lectura fragmentada
(Fragmented Reading), 2013**
Artist's editions, plate with a piece
of a book: 1⅜ × 7½ in. (3.5 × 19 cm),
book: 13⅜ × 9 × 1¼ in. (34 × 23 x 3 cm)
Collection of the artist.

**Jardín interior (Indoor Garden),
Series I, No. 1, 2003**
Photograph of the installation
(bows from women's lingerie on natural
stalks), 2 ft. 7½ in. × 3 ft. 11¼ in.
(80 × 120 cm)
Collection of the artist.

***Sueño de verano: El horizonte es una ilusión** (**Summer Dream: The Horizon is an Illusion**),* 2012
Enlargement of a photo showing maps of the Miami coast and Havana in front of a swimming pool
Focsa Building, Havana.

ALEXIS LEYVA MACHADO, KNOWN AS "KCHO"

You want to know my theory on the purpose of art? Some will say it serves several purposes. As for myself, after much thought I've reached the happy conclusion that art has but one significant, unique, and magical aim, and that is to accompany man, to help him, to teach him how to grow, to transform what he thinks into a reality. Art can therefore create happiness, which gives it a magical dimension.

But, on closer analysis, alongside art's essential aim of accompanying us through life, it's always had a deceptive, consumerist element. That's why I do what I do. I try to defend art's primary purpose. I've come to the conclusion that art, the artwork, and the artist are not—nor should they be—remote from reality, from society, from people. Artists are important, very useful components in society, as long as they understand their true role. That's why I say that my deepest concern as an artist is to do good.

In this context, it's impossible to talk about art without talking about the revolution. I believe the most significant work ever to exist in Cuba is the Cuban Revolution. Why? Because it was capable of distilling everything that was of fundamental importance, turning it into an incontrovertible reality that changed the country. That's how the world changes. This goes beyond Kcho, beyond Lam, beyond Amelia Peláez.... That's what being Cuban means.

There's this current of transformation, which is capable of going all the way to Africa and helping it out, and it's great. Our blood, our culture, our spirituality come from Africa. And so Cubans went to Angola and other countries in Africa to change their destiny. It's something that needs to be talked about, it's really important. That's what this country did for art during the revolution.

**Born in 1970 in Nueva Gerona,
Isla de la Juventud.
Lives and works in Havana.**

Isla de la Juventud

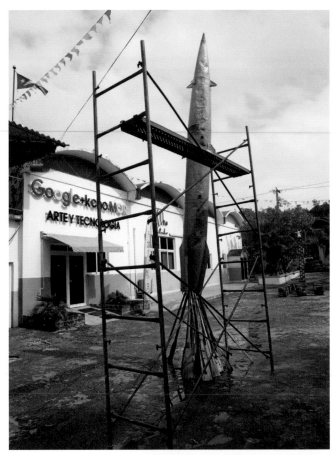

―――――――

Views of Kcho's studio.

That's the aim of what we're doing here, of my work: to be close to the people when they need it. No one can take this place away: it will always be in Cuba. Everything I've acquired, accumulated … it'll always remain in Cuba.

Fidel Castro once said that the future of Cuba lay in science, and that we had to start working hard to change everything. A large number of engineers, architects, chemists, and IT specialists got the necessary qualifications and changed the landscape of the country. The environment in which they trained was highly conducive, thanks to what Fidel introduced: a school, a structure, a range of values. It provided an ideal context for education, for training those who will change things in the future. I have absolute confidence that this remains possible, and that this is the only possible path for life and art. Why? Because if art continues to transform itself into a mere commodity, if it falls short of its true worth, we're headed nowhere.

My commitment to art is present in everything I do. And if I defend this conception of art head-on, it's because art can be a powerful force: it can change things for the good, but it can also do a lot of harm. ▬

—
Kcho's studio.

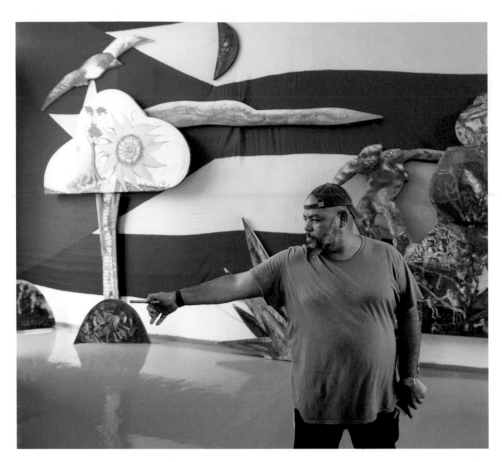

Kcho's studio.

**Plan Jaba
(The Jaba Plan),
1991**
Sculpture with
compost made of
branches and palms,
8 ft. 2⅜ in. × 3 ft. 3⅜ in.
× 1 ft. 11⅝ in.
(250 × 100 × 60 cm)
Collection of the artist.

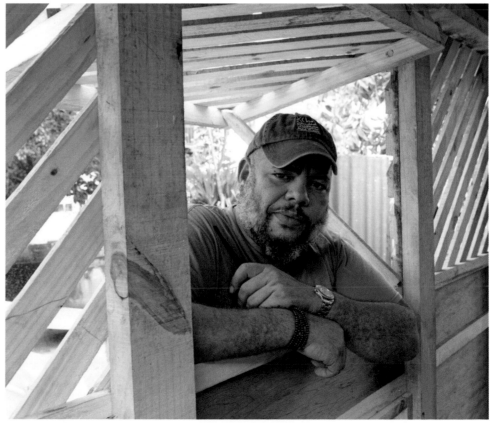

El David (**David**),
2009
Wood, rope, metal,
barrels, and video,
variable dimensions
Collection of the artist.

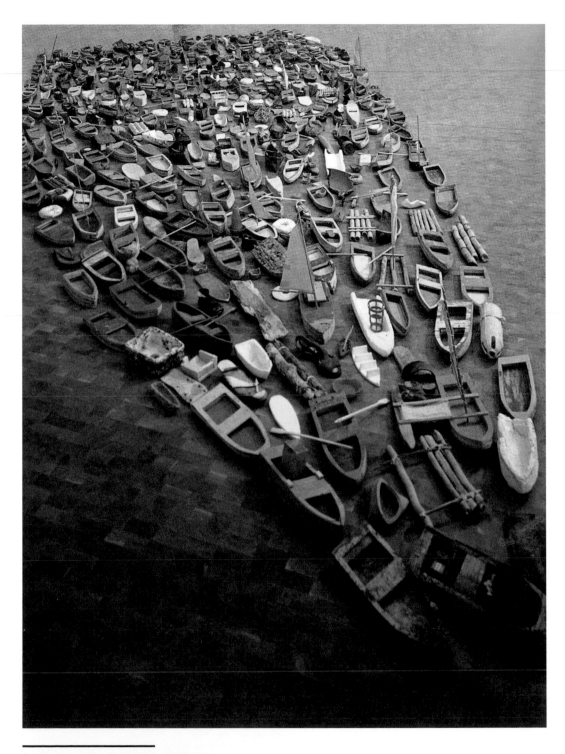

La Regata (*The Regatta*), 1993–94
Wood, plastic, metal, ceramics, and everyday
articles, variable dimensions
Museum Ludwig, Cologne.

REYNIER
LEYVA NOVO

I studied at San Alejandro, and then at the ISA from 2004 to 2008. But I'm not a graduate of the ISA; I gave up in the fourth year, one year before finishing.

Since my time at San Alejandro, I've continued to attach special importance to the initial concept of an artwork and to researching it thoroughly. The works materialize in very different ways. A certain number of years have passed, and up till now I've done only two or three similar works. For me, it's the idea itself that is key.

My work is connected with how I read. I read several books at the same time, and that's also how I work. I work slowly on approximately five projects, all at once. I spend a lot of time working on invisible projects, artworks that are never seen. I can spend months refining a list of countries that will help me shape a work.

I dedicate a lot of time to research: on how to translate the power of the image, on things that interest me. Some time later, this research will be transformed into a visible, concrete, specific work. In parallel, I produce my artworks. I don't do the majority of the pieces in Cuba, since often I don't have the materials or equipment to produce them. That's not unique to me: some 1960s artists even directed their works by telephone.

I think up the majority of my works— conceptually as well as formally—in my studio,

Born in 1983 in Havana.
Lives and works in Havana.

Havana

at home, and then, using email or video chat, I connect with places elsewhere in the world that produce the type of work I want to make. I send them all the instructions, and some time passes before I get to see my work. If a piece is produced in the United States, I often don't see it at all before it's shipped and exhibited. At the moment my work is like pushing a mountain over the sea or plowing the sea. If you visit my home or my studio you'll hardly see anything at all. If I show you a presentation on the computer, perhaps you'll understand a little better the body of work I've built up over all these years, but the work's not consolidated in practical terms until it's exhibited. It's not like a painter working quietly in a studio, who can make an infinite number of colors from just three: his reality, his art, is in front of him. He can spend an hour, a minute, a hundred days working on it, but when he's finished, that's it, right in front of him. ▬

*Palabras de piedra. Arquitecturas de poder
de un país heredado (Stone Words. Architecture
of Power in an Inherited Country)*, 2016
Earthenware fresco (Jaimanita stone; green, cream,
and black marble; Gray Siboney marble), variable dimensions
Collection of the UNAICC (Unión de Arquitectos e Ingenieros
de la Construcción de Cuba), Havana.

**Reynier Leyva Novo's
studio.**

Sin título—*Familias obreras cubanas*
(Untitled—*Familial Cuban Works***), 2018**
Carpet made of Cuban workers' clothing,
13 ft. 1½ in. × 14 ft. 1⅓ in. (4 × 4.3 m)
Collection of the artist.

El beso de Cristal
(**The Kiss of Crystal**), 2015
70 stem glasses, variable dimensions
Art Gallery of Ontario, Toronto.

El deseo de morir por otros
(**The Desire to Die for Others**),
2012
Polyester resin cast of a pistol,
variable dimensions
Private collection.

MANUEL
MENDIVE HOYO

My painting comes from my mixed-race roots, as I have Hispanic and African origins. Afro-Cuban culture results from a meeting of different ethnicities. I try to construct a discourse on this basis, taking account of the concessions, hopes, and concepts shared by Afro-Cuban culture.

All mythologies and cultures carry within them a great truth. This is what enables us to overcome our contradictions. This is why I think that faith helps so much. Even if somebody thinks they're lacking faith, they will have it unconsciously, because faith is also hope, and everyone has hope. It's faith that drives me to paint. Faith in the interview we're doing; faith that people will read it, that it will be worthwhile and make sense.

I would not make the same comments to a critic as I would to the audience that comes to see my work. Informed critics can evaluate. They've studied. They have their own concepts. They are abreast of the trends, of artistic events. They possess a solid foundation that means they can talk technically. What's most important to me, though, is that a painting should slowly enter the eyes of the person looking at it and touch their heart, be they critics or just viewers.

Aside from my painting, I also carry out performances. In performance you can express many things in a different way from painting. It's a way of implicating the viewer in my conversation, in my creation—making the public participate in what I'm saying even as they visualize it. ▬

**Born in 1944 in Havana.
Lives and works in Havana.**

Havana

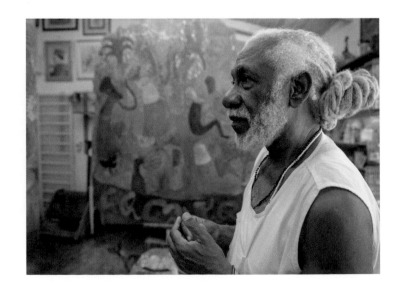

Manuel Mendive Hoyo's studio.

Manuel Mendive Hoyo's
garden studio.

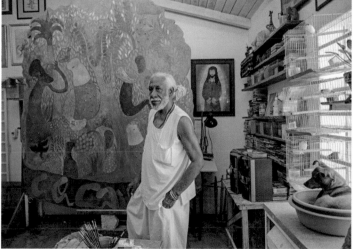

Manuel Mendive Hoyo's studio.

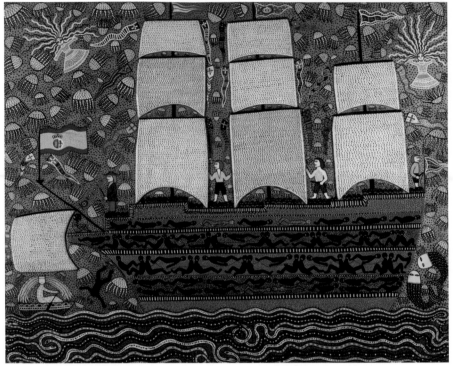

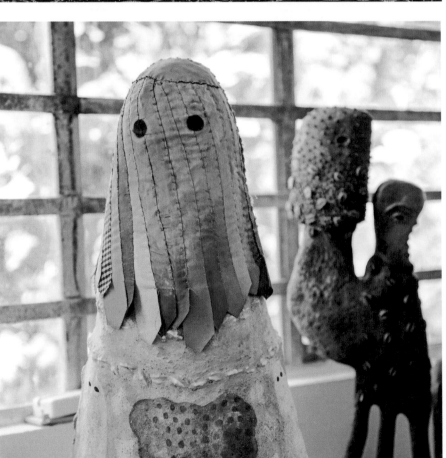

Top

─────────────

***Barco negrero (Slave Ship)*, 1976**
Oil on wood, 3 ft. 4⅛ in. × 4 ft. 1⅝ in.
(1.02 × 1.26 m)
Museo Nacional de Bellas Artes, Havana.

Above

─────────────

***Cabeza de pez con hombre
(Fish Head with Man)*, from
the series *Para el ojo que mira
(For the Seeing Eye)*, 1987**
Soft sculpture,
3 ft. 8⅛ in. × 1 ft. 9¼ in. × 5⅞ in.
(112 × 54 × 15 cm)
Collection of the artist.

Left

─

***Eggun*, 1996**
Oil paint and cement,
27⅛ × 15⅜ × 13¾ in. (69 × 39 × 35 cm)
Collection of the artist.

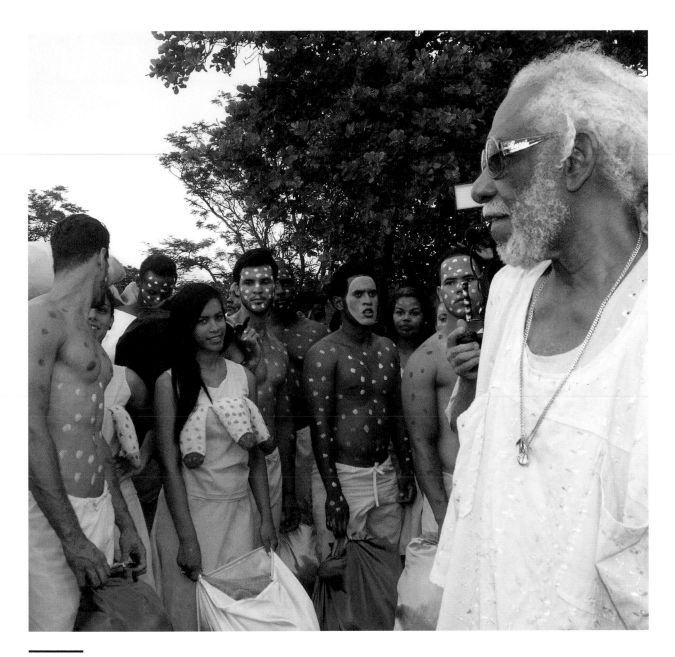

Performance, 2009.

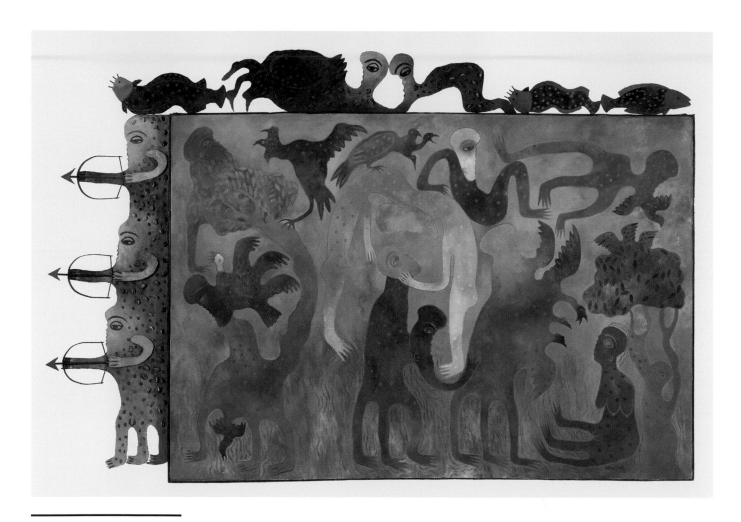

***El espíritu, la naturaleza y las cabezas
(The Spirit, Nature, and the Heads),
2009***
Oil on canvas and metal,
6 ft. 7½ in. × 9 ft. 10⅞ in. (2 × 3 m)
Centre Pompidou – Musée National d'Art
Moderne, Paris.

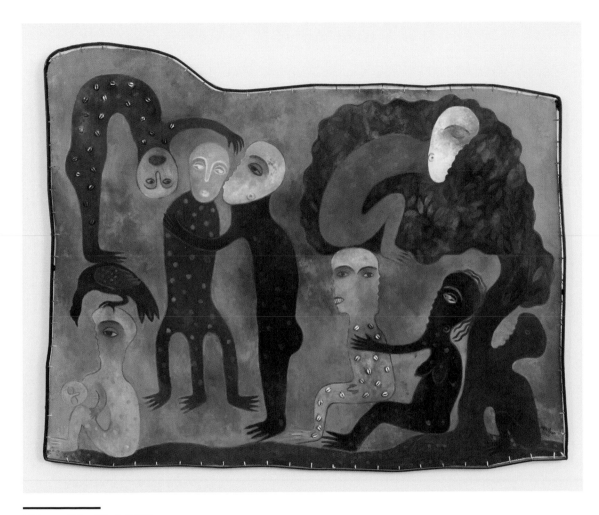

El beso (*The Kiss*), 2010
Mixed technique on canvas with metal,
4 ft. 4⅜ in. × 5 ft. 4½ in. (1.33 × 1.64 m)
Private collection.

JOSÉ MANUEL
MESÍAS

I've continued to work on several themes I embarked on at the San Alejandro school. It all began in a very fragmentary way. I've always been interested in history. I work with the idea of symbols. I've always been interested in remnants and salvage, and in how they might illustrate truths that sometimes we do not perceive in reality. I continue to draw on many works I produced during my studies. I may still exhibit them. The broad outline of my work still harks back to that time.

I produce large-format paintings and make objects, too. My series of works *Aun y desde entonces. Versos y teoremas* (Now and since that time: verses and theorems) and *Podriamos nombrar el nombre* (We can name the name) are half assemblages, while others are found objects. The concept of the *objet trouvé* lets me do something that painting does not. Working with the object is unpredictable. What takes months to achieve with a large painting is immediately possible with an object. I compare

**Born in 1990 in Havana.
Lives and works in Havana.**

Havana

José Manuel Mesías in his studio.

painting to a long poem with many lines, and the object to a brief poem like a *haiku*.

For me, the object has become a way of approaching highly subjective questions: it establishes a connection between spiritual, mystic, and religious thought, and a more rational, scientific vision of the world. I use objects from daily life that inevitably retain a local flavor, even though that's not the reason for the work. They convey a notion of the space in which I move, the environment from which I come.

The series *Era de la Independencia* (The era of independence) comprises large-size paintings on a historical theme. When I began these works, I wanted to produce something that resembled images characteristic of that period, which I found very mysterious and very interesting, because it was when the notion of "country" was constructed. I always use the word "notion" because it refers to something that is not a definite concept and cannot be described. Neither is it anything tangible or concrete. When a person has a "notion," it's something etched into their imaginations, something that is hard to make real, which is why I like the idea.

In my opinion, notions are almost always manifested visually. What interested me in this series was trying to use pictures to constitute a corpus, an index, of this period in the second half of the nineteenth century when the Cuban Wars of Independence took place. I say "index," because the work is like an unfinished book that gradually fills up. I hope this series of paintings about the history of Cuba—the way I've translated the history of Cuba, at any rate—proves of universal interest. And that a viewer from, say, China or Japan will be able to understand it. ▬

Cabeza de caballo
(*Horse's Head*), 2016
Oil on canvas,
4 ft. 10¼ in. × 2 ft. 1⅝ in.
(148 × 65 cm)
Collection of the artist.

José Manuel Mesías's studio.

La muerte de Maceo—Rectificaciones a la obra de Armando Menocal (*The Death of Maceo—Rectifications of the Work of Armando Menocal*), **2013–17**
Oil on canvas, 9 ft. 10⅞ in. × 14 ft. 8¾ in. (3 × 4.49 m)
Collection of the artist.

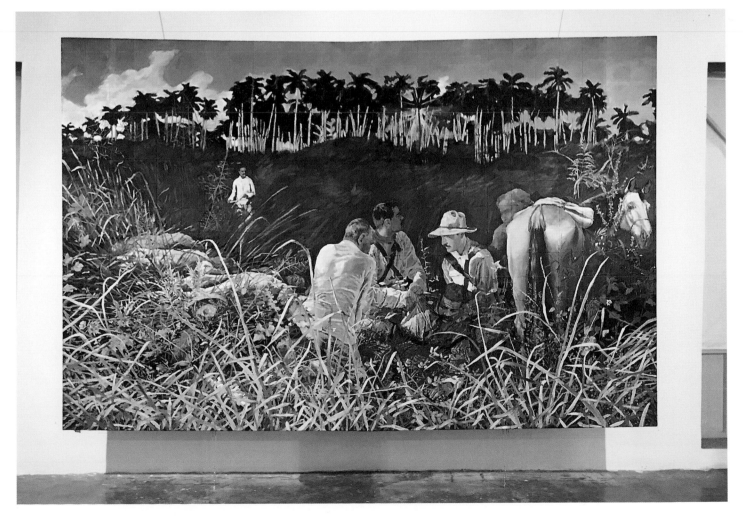

José Manuel
Mesías's solo
exhibition at the
Factoría Habana,
2017.

MICHEL PÉREZ
POLLO

I'd say that about 80 percent of my work is preparing the ground for painting. This involves working with models, with objects I come across by chance in the street, or with objects I make myself. These are the elements I use to construct my work.

Occasionally I paint from scratch. This allows me a greater degree of freedom, because I can compose my painting entirely in my head. Every time you do a painting starting from a model—from reality—you're representing a specific form, a concrete, recognizable form. When I go without a physical model, however, I can create shapes that are unrecognizable, more abstract.

Another significant component of my work is undoubtedly the relationship between different, apparently irreconcilable objects. It's an idea I took from the surrealists, whose *Manifesto* states that a relationship between two random things generates a poetic state. On other occasions, I manipulate existing objects, trying to divorce them from their functionality, their essence, and to transform them into something else.

In the end, I guess I follow the entire creative process with the end result, the picture, in mind. That's why, from the very start,

**Born in 1981 in Manzanillo.
Lives and works in Havana.**

Manzanillo

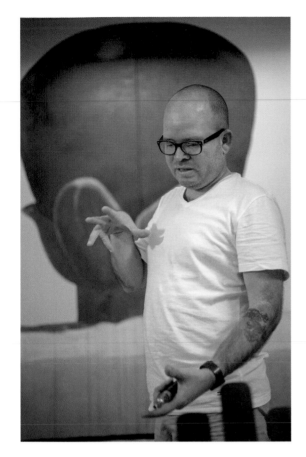

Michel Pérez Pollo's studio.

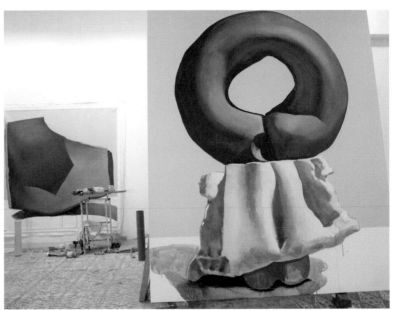

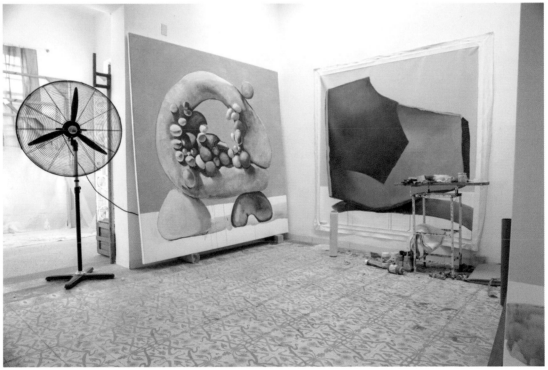

**Michel Pérez Pollo
in the yard of his studio.**

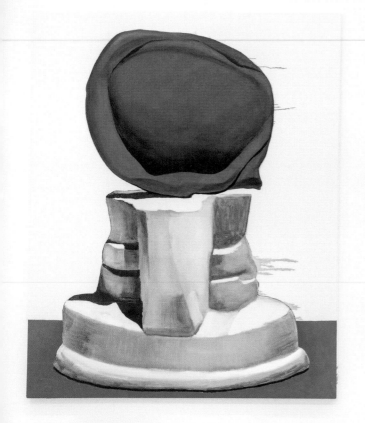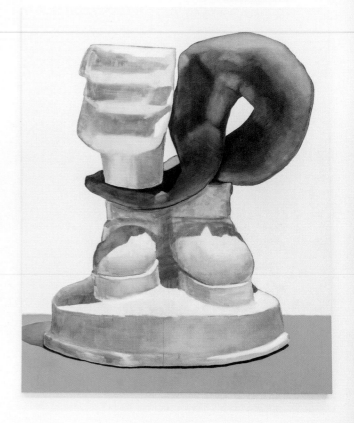

—
Mattias, **2017**
Oil on canvas,
8 ft. 2⅜ in. × 6 ft. 6¾ in. (2.5 × 2 m)
Private collection.

as soon as I begin working with a model I think in terms of form, color, and composition. Basically, I'm painting as soon as I start to build the model. From that moment, I make decisions about colors, shapes, etc. For me, it's like constructing a figure. There are many different and apparently incompatible factors to take into account but, in the end, there's a physical relationship between these elements, resulting in a composition that somehow slots these elements together. **—**

Michel Pérez Pollo's studio.

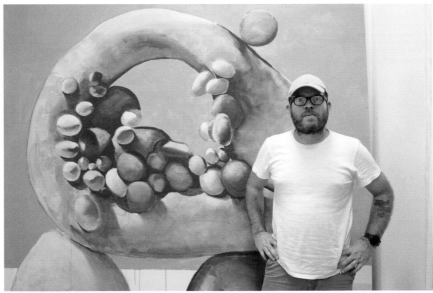

Above

Michel Pérez Pollo in front of his work *Granada*, 2013.

Santiago, 2017
Oil on canvas,
8 ft. 2⅜ in. × 6 ft. 6¾ in. (2.5 × 2 m)
Private collection.

Bodegón (Still Life), 2011
Acrylic on canvas, 4 ft. 11 in. × 4 ft. 11 in
(1.5 × 1.5 m)
Private collection.

MABEL
POBLET

I come from Cienfuegos, a province to the south of the island's center. At the age of sixteen, I moved to Havana to continue my studies at San Alejandro because I wanted to learn engraving.

My work has always been self-referential. I deal a lot with my own history, my past, my childhood, my hometown. It is thanks to all this that I started making art, as a means of expressing my nostalgia for Cienfuegos. Then I began working on memory and recollection: the image of a person you lost that comes back to you, for instance. How can you recall a fragment of a face from a portrait, but without ever managing to see it in its entirety?

When I do printmaking (I currently use silkscreen), what interests me is creating a single image out of the same repeated element. Seriality reminded me a little of time, of the constancy of days.

When I went to the ISA, my horizons broadened. I moved away from self-referential work and focused more on the lives and histories of other people. I had an exhibition at the Villa Manuela gallery where I worked on the image of Ana, a girl who died of leukemia. I constructed her portrait out of medicine bottles, as if to replace her blood and thus bring her back to life.

Then I embarked on a series entitled *Simplemente bella* (Simply beautiful). The work arose from a prison visit. I was motivated by the fact that, even in a place as depressing as a prison, you can find beauty or meet people

***Trillizas (Triplets)*, from the series**
***Desapariencia (Dis-appearance)*, 2013**
Photograph on PVC, silkscreened flowers on
acetate, 3 ft. 3⅜ in. × 4 ft. 11 in. (1 × 1.5 m)
Consejo Nacional de las Artes Plásticas (CNAP),
Havana.

Retrato (Portrait)*, from the series *Imagen
***no palabra (Picture, Not Words)*, 2010**
Drawing on plastic, silkscreened letters on
acetate, 4 ft. × 26 ft. 3 in. (1.2 × 8 m)
Private collection.

Silencio (Silence)*, from the series *Imagen
***no palabra (Picture, Not Words)*, 2010**
Drawing on plastic, silkscreened letters on
acetate, 4 ft. × 26 ft. 3 in. (1.2 × 8 m)
Private collection.

**Born in 1986 in Cienfuegos.
Lives and works in Havana.**

Cienfuegos

searching for beauty. I was especially affected
by seeing prisoners making plastic flowers (very
kitsch, it has to be said; an imitation of kitsch
using kitsch).

I produced another series called
Desaparencia (Disappearance) that touches
on the search for physical rather than spiritual
beauty. Physical beauty is often accompanied
by intense inner suffering.

I still produce installations. Recently,
I've concentrated more on social issues, in
particular in the *Patria* series that I presented
at the Havana Biennial in 2015. In this piece,
I tackled the social problems we all experience
in Cuba. The painted, see-through texts

reconfigure several different concepts, touching
on what the notion of homeland might mean
for those who lived through the revolutionary
process, as well as those who didn't. That's
what Cuba is for me today, this mixture of all
and nothing. Viewers could decipher all this in
the artwork's shadows. ▬

Facing page

Performance from the series *Patria* (*Fatherland*), 2016
Variable dimensions
Performance at the Smithsonian American Art Museum, Washington D.C.

Top

***Ocean Scape*, from the series *Diario de viaje* (*Travel Journal*), 2018**
Photographs on PVC, diam. 32 in. (81.3 cm)
Galerie Artemorfosis, Switzerland.

Bottom

***City Scape*, from the series *Diario de viaje* (*Travel Journal*), 2018**
Photographs on PVC, diam. 3 ft. 11¼ in. (1.2 m)
Collection of the artist.

Buoyancy, from the series
Buoyancy, 2018
Video and audio installation,
variable dimensions
Piece created in collaboration
with the composer Andrés Levin
Collection of the artist.

Mabel Poblet in her studio.

EDUARDO
PONJUÁN
GONZÁLEZ

I was born in 1956. Early on in the revolution, at the age of five, a man who painted names on the side of boats gave me my first art lessons. Then someone suggested that I might become an art instructor, well before the creation of schools for art instructors. In those days, when it looked as though someone might have a predilection for drawing or painting, they were allowed to embark on an artistic career. That's how I took my first courses in art at primary school. A friend who was to sit the school entrance exam asked me to accompany him.

In my village there was no art school, or museum, or gallery, and only one primary school. I went with him. I was really timid. I still am. I was sitting outside, and a teacher came out, saying: "Come on, I've got other exams to look after." As I hadn't come to sit an examination, I just stayed put. But he said, "Come on, come on, what are you waiting for?" I went in and did the exam. I passed, whereas my friend failed. It's ironic. That's how I got into art school: entirely by chance.

Once at the school, I had marvelous teachers who nowadays are important artists, such as Jorge Rodriguez and Tiburcio Lorenzo, a Cuban landscape designer. The teacher who helped me the most was the great Pedro Pablo Oliva.

Born in 1956 in Pinar del Río. Lives and works in Havana.

Pinar del Río

Eduardo Ponjuán González
in his studio.

Monumento (Monument), 2003–6
Sculpture made of Cuban 20-centavo
coins, ⅞ in. × 5 ft. 6¼ in. (2.4 × 168 cm),
equaling the height of the artist
Edition of 3
Alyn Ryan Collection, London (1/3)
Andreas Winkler Collection,
Lucerne and Havana (2/3)
Museo Nacional de Bellas Artes,
Havana (3/3).

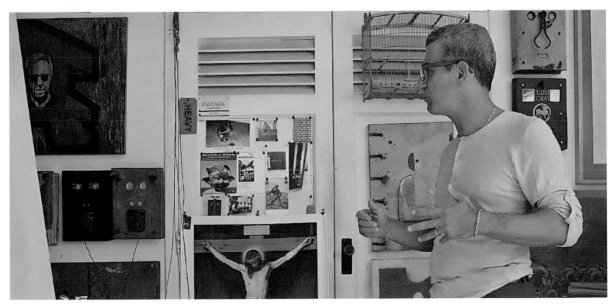

I then studied at the ENA, having sat and passed the examination. I took my diploma, doing my civilian service at Pinar del Río, where I looked after the gallery there. Then I returned to Havana. I sat an exam at the National School of Art and I taught there for twenty years. That's the story of my connection with the institution.

Over the forty years that I've been doing art, I've focused on various issues. At one time I was concerned with beauty, with form; at other times with reality, utopia, with making changes to life. Occasionally I am quite pessimistic and believe in absolutely nothing. At other times I regain my confidence.

There is an anecdote about Paul Valéry, I think it is. When asked what he was trying to say with his poems, he replied that what he meant was what he'd done. I like that idea a lot. At every moment, what I'm doing is what I want to say. ▬

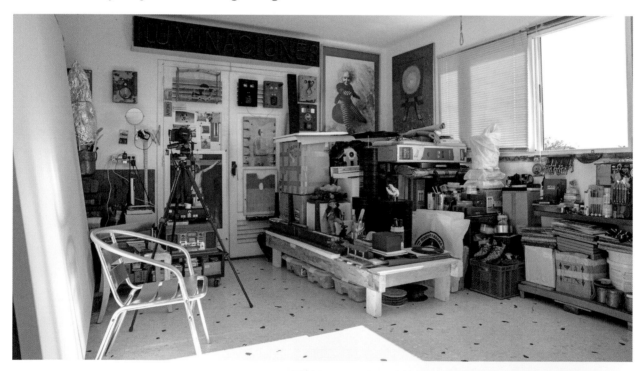

Eduardo Ponjuán González's studio.

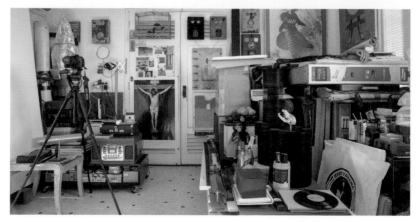

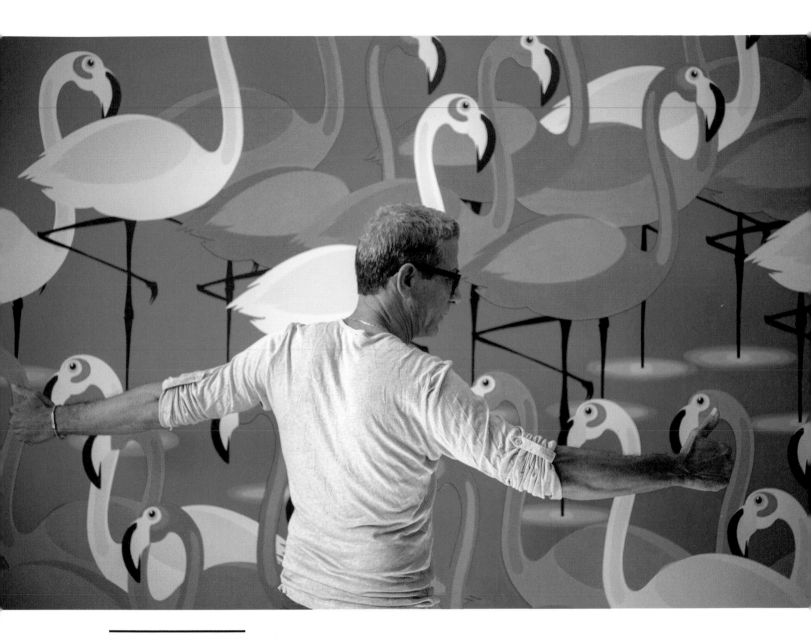

**Eduardo Ponjuán González in front
of his work *Flamingos* (detail), 2018.**

Hecho a mano
(*Handmade*)**, 1991**
Oil on canvas,
4 ft. 7⅛ in. × 3 ft. 11¼ in.
(1.4 × 1.2 m)
Private collection.

Postneón, **1991**
Oil on canvas,
5 ft. 2⅜ in. × 3 ft. 8⅞ in.
(1.59 × 1.14 m)
Xin Dong Cheng
Collection, Beijing.

Desgarrón (*Torn Paper*), 2014
Oil on canvas,
6 ft. 6¼ in. × 8 ft. 2⅜ in. (2 × 2.5 m)
Susiz and Mitchell Rice Collection,
Tampa, Florida.

WILFREDO
PRIETO

I studied art for twelve years: three years at elementary level, four at intermediate, and five at the Higher Institute of Art. To an extent, the education program at the ISA is a far cry from a university curriculum, because you're always thinking about embarking on a professional career while you're still a student. We took part in the Havana Biennial while we were students. This forces you to have more confidence in yourself, and makes you able to deal with more complex situations involving a critical public. After that, I spent almost twelve years outside Cuba, living in Spain, then for a brief time lived in France, in Amsterdam, and a little in New York.

I'd say that what I try to achieve in my art is a simple translation of how I live, of my experience, my concerns, my circumstances. For me, it's hard to classify it, to give it a form. What I can say is that I'm very interested in reality. I like to talk about reality using reality, not relying on consensus or stealth.

Sculpture has a life of its own. It has real substance: it has smell, weight, meaning, and a context in which it was made. It's like I'm exploring the same thing all the time: it's life that really introduces me to new forms.

My current project is shaped by a debt I feel toward myself, toward my education, and springs from my return to Cuba. Well, not exactly that: rather the fact that, now I've spent a little more time here, I can understand my circumstances afresh, the stages that one has to live through.

**Born in 1978 in Sancti Spíritus.
Lives and works in Havana.**

Sancti Spíritus

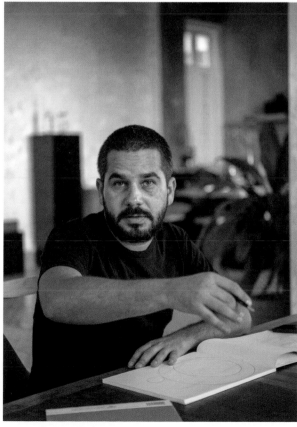

Wilfredo Prieto in his studio.

Wilfredo Prieto presenting
his piece *Cuanto más añades,
menos ves* (*The More You
Add, the Less You See*), 2011.

Apolitical, 2001
Flags and poles, variable
dimensions
View of the installation
at the FIAC 2006 in
the Jardin des Tuileries, Paris.

Poème fini (Finished Poem), 2001
Coins, variable dimensions
Collection of the artist.

Wilfredo Prieto in his studio.

Along with a group of friends, I'd like to establish a center in which experimentation can have its place, almost in its purest sense. I believe that, against the backdrop of universalization and the global standardization of the art market, of information, it's really important to experiment and to experience creative freedom. In this sense, I feel I represent a very specific point of view, an artistic standpoint that cannot be found in any institution.

My view is that there is not one type of experimental art—that there are as many variations as there are artists, as there are people living within our culture. It's important to defend this territory and to appreciate its values. I think all this can have a social impact, that everyone can add their contribution. ▬

Miren el tamaño de este mango
(***Look at the Size of That Mango***), 2011
BlackBerry, mango, elastic band,
c. 4 × 4¾ in. (10 × 12 cm)
Private collection.

Cuanto más añades, menos ves
(***The More You Add, the Less You See***), 2011
Transparent stretch film, h. 5 ft. 7 in. (1.7 m)
Private collection.

SANDRA
RAMOS
LORENZO

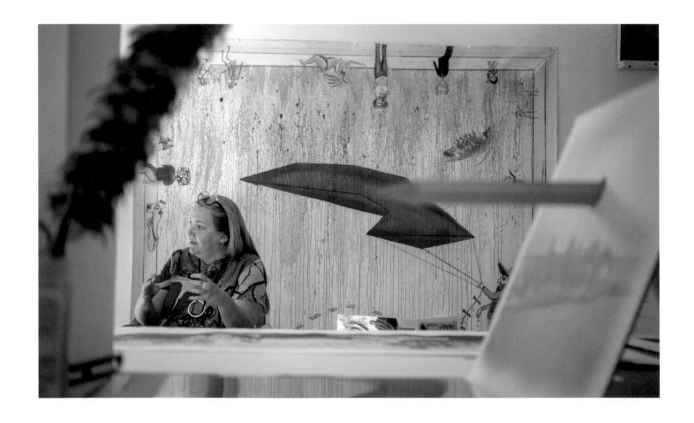

Born in 1969 in Havana.
Lives and works in Miami and Havana.

Havana

My work is a kind of diary of my life, of what I think, of what I've learnt. It's always been my way of learning about the world, of questioning it and of voicing my opinions about it—as I've done by borrowing the figure of the pioneer, which I've been using all my life.

I've been told it's a self-portrait, but I don't think it is. It is a character that's based on my experiences but tries to go beyond that. It relates to a collective experience that has to do with the revolutionary process, the evolution of Cuban society, the island's history. It's as if I am replaying the history of Cuba through this character: I look at the past and the present, and I imagine what the future will look like.

It's something I regard as quite personal, like painting. I enjoy making installations, but these characters never appear in the installations or other artworks. That's a completely different series. What interests me in the installations is the participative aspect: how the public takes part in the piece and enters into a relationship with the visual art event, enriching it and becoming enriched themselves through their lived experience of a work.

The most important thing for me is the fact that my work saves me as a human being. It allows me to remain stable, because I can concentrate on my work and leave everything else behind. ▬

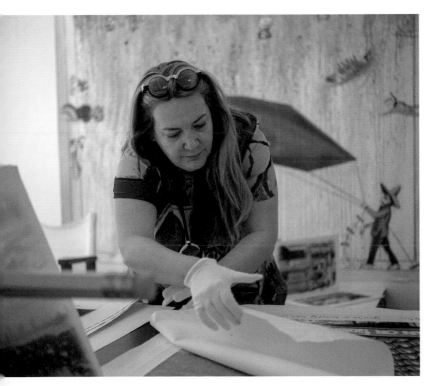

5 maneras de torturar mi alma y mi cuerpo (Five Ways of Torturing My Soul and Body), 2009
Etching and aquatint, 8⅝ × 11⅝ in. (22 × 29.5 cm)
Private collection, United States.

Sandra Ramos Lorenzo in her studio.

185

Sandra Ramos Lorenzo
in her studio.

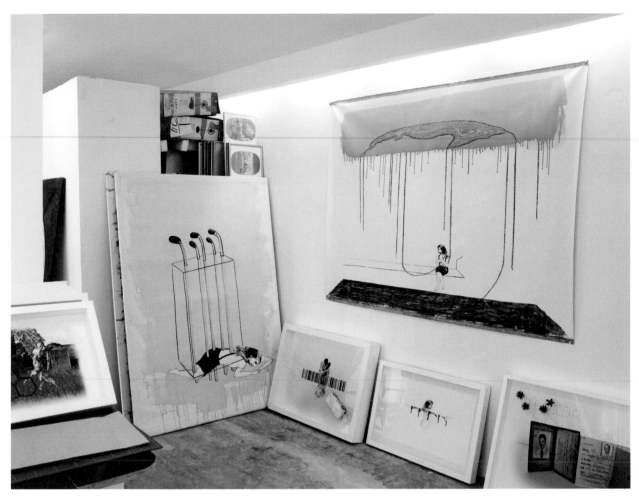

Sandra Ramos Lorenzo's
studio.

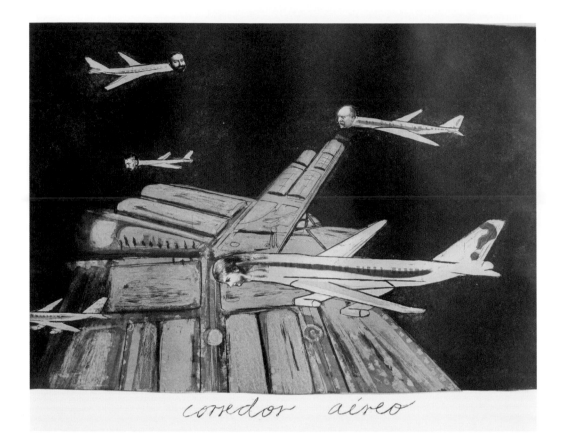

corredor aéreo

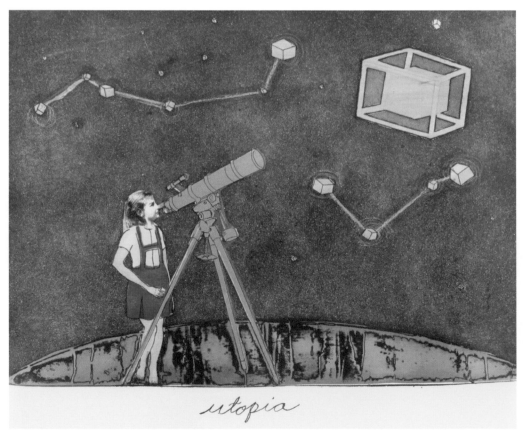

utopia

**Corredor aéreo
(Aerial Corridor), 2010**
Etching and aquatint,
19⅝ × 23⅝ in.
(50 × 60 cm)
Private collection,
United States.

Utopía (Utopia), 2010
Etching and aquatint,
19⅝ × 23⅝ in.
(50 × 60 cm)
The Alfond Collection
of Contemporary Art
at Rollins College,
Winter Park, Florida.

El punto cercano más lejano
(**The Farthest Near Point**), 2012
Video installation, variable dimensions
Collection of the artist.

**Sandra Ramos Lorenzo's studio
yard.**

LÁZARO
SAAVEDRA

What I'm interested in is positioning my works not so much as answers, but as questions that spur viewers to look within themselves for answers. To a certain extent, I'm trying to get the creative act to repeat itself.

Artists never say: "This is the right answer to this question." Instead, they wonder how many appropriate answers there might be. That's why the process of examination and research is inescapable. It enables you to come up with results such as 2+2 = 5. In science, 4 is the answer to the question 2+2; but in art, you can formulate your response from another viewpoint, using your imagination or your talent for polemic—whatever your work stimulates. This is why I'm also interested in boosting the potential of an artwork as a means of communication.

The word "language" implies the action of two functions: the cognitive function and the communicative function. When you activate the cognitive function, you're not entering into the language of art: you're manipulating it to catapult yourself into another reality that is not the reality of poetic or aesthetic construction. And this throws up another problem. When you prompt the cognitive function, the communicative function makes the relationship between the work and its viewer fluid. I'm not looking to force this relationship or to bamboozle viewers with barriers, because my

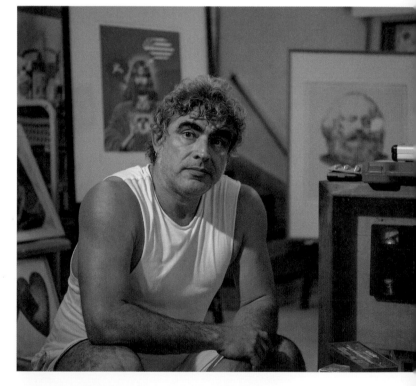

concern is to encourage ideas to develop in their minds.

When I started out, artists and movements such as the conceptual movement exerted a huge influence over me. Goya was very important. I studied Goya's *Caprichos* engravings in depth. I still harbor a great admiration for his oeuvre, and that is going to stay with me for the rest of my life.

**Born in 1964 in Havana.
Lives and works in Havana.**

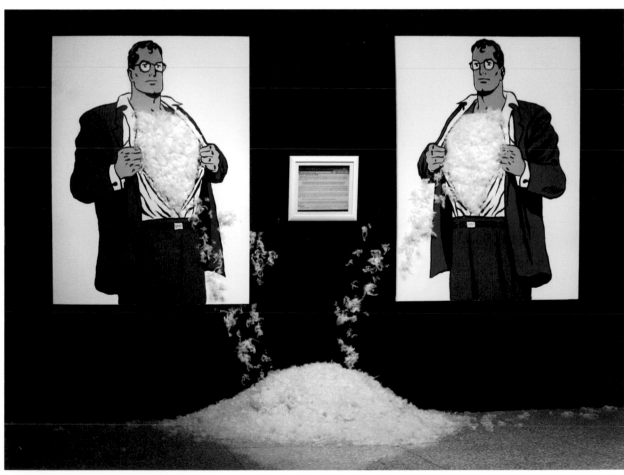

**Untitled, from the series *Solidificando
lo que se desvanece en el aire* (*Solidifying
What Dissipates into the Air*), detail, 2013**
Mixed technique, variable dimensions
Consejo Nacional de las Artes Plásticas (CNAP), Havana.

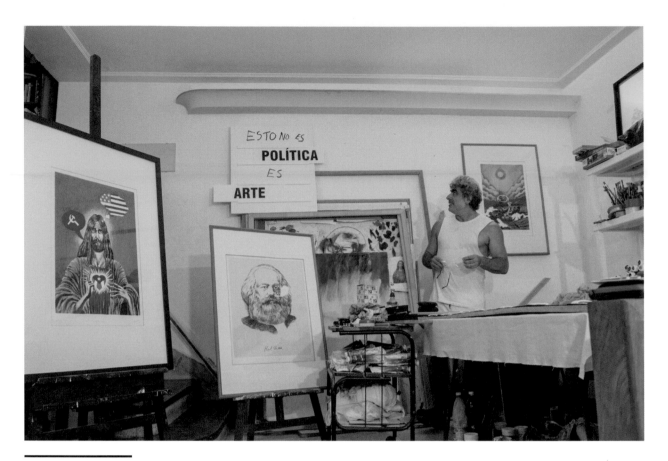

Lázaro Saavedra in his studio.

To an extent, my work is closely linked to the way humor, graphic humor, is handled. Other artists have taken the comic strip and attempted to turn it into a kind of social critique. On the linguistic level, graphic humor has also influenced me a lot. I owe a great deal to the tradition of graphic humor.

To explain my working processes, I apply a methodology I try to teach my students as well. It's a theory of activity that's very simple. An activity is a process with an objective—it's something you are aiming to achieve. There's a *before* and an *after*, connected by means of a process that, in certain cases, is linked to your chosen strategy. The process is closely related to the methods you use; to undertake an activity and to attain your goal, you make use of certain things, you employ materials. That's what it's easiest to plan for. But internal processes—ones that prompt the questions "Why?" (What is your motivation?), "To what end?" (What is your aim?), and "How?", and that compel the artist to create—can get lost or become altered over time, and are difficult, but not impossible, to conceptualize. ▬

View of the Venice Biennale, 2013.

Relación profesional (*Professional Relationship*), 2008
Video, 44 sec.
Collection of the artist.

Debajo de esta obra hay un gran concepto (*Beneath this Piece There's a Great Concept*), 2013
Installation, variable dimensions
Collection of the artist.

Facing page

Arte contestatario (*Protest Art*), 2015
Canvas on stretcher and paint on wall, variable dimensions
Musée d'Art Contemporain, Rochechouart.

Lázaro Saavedra
in his studio.

Guerreros herméticos
(*Hermetic Warriors*), 2010
Graffiti on cardboard,
3 ft. 3⅛ in. × 2 ft. 3½ in.
(100 × 70 cm)
Private collection.

Facing page

Untitled, 1989
Mixed technique, variable
dimensions
Private collection, Germany.

ESTERIO
SEGURA MORA

From the age of four to eight, I was a child who spent his time observing, works of art in particular. I remember that my first critical take on art came from books my father owned about the colonization of America. The illustrations were very interesting: engravings from the eighteenth or nineteenth century. From the age of eight I began to draw all the time. I entered the School of Art at twelve, having passed the entrance examination. My teachers had all said that my grades were satisfactory, but that they weren't improving because I spent all my time drawing, so they decided that it would be best for me to pursue my studies at the School of Art. That really did change my life. I did nothing except think about art, and I've continued to live according to its demands.

From that point on, I've primarily chosen to produce art as if I were doing a self-portrait of my life. I've this idea of my art as a portrait of my existence and of my passing through this world. I've always enjoyed learning about everything, for the simple reason that no technique, no specific artistic process, no style, interests me particularly. I'm interested in whatever process will best help me convey a concept for a specific piece. While I was

Born in 1970 in Santiago de Cuba.
Lives and works in Havana.

Santiago de Cuba

Esterio Segura Mora's
studio.

still learning the basics, I strove to learn about everything that passed my way: photography, drawing, painting, engraving, sculpture, the concept of installation, theater, dance.

It is hard for me to talk about my work without going off in different directions. At the present moment, I'm working on ten projects I've been involved in for twenty-five years, all at the same time. In my works I refer as much to the evolution of culture as to the influence of the numerous different political and cultural traditions that shape Cuban culture, such as kitsch, baroque, rococo, neoclassicism, and eclecticism. All of these styles are mixed up with the political symbolism you can find behind a large number of my artworks. Moreover, I've gone back to the sculptures I produced for the film *Fresa y Chocolate* (*Strawberry and Chocolate*, 1994).

Some themes and symbols also appear repeatedly in my art: travel, flight, the airplane, Pinocchio, lying, darkness, truth. In fact, these

Esterio Segura Mora's studio.

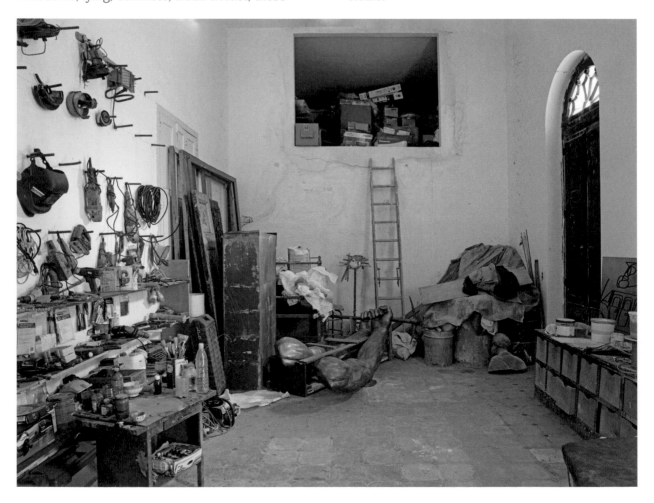

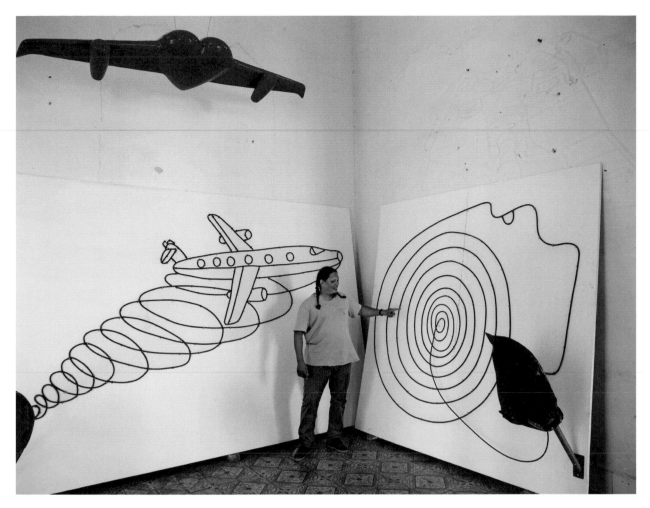

**Esterio Segura Mora
in his studio.**

terms relate to social, political, and historical phenomena. The story of Pinocchio, for example, touches on the question of how history has been, and still is being, manipulated. History never comes down to us just as it is: it is always a manipulation of history, until it ends up eating its own tail. That's why my series of works featuring Pinocchio is called *History Eats Its Tail*—because, in the end, history coils in on itself and rediscovers itself.

As for the theme of flight, its origins are very personal. Independently of the fact that I liked making art, learning how to fly has been a passion of mine since childhood. Until I was twelve, I used to swear by Leonardo da Vinci—not as a painter, but because he had invented flying machines. For a long time, I even considered his *Mona Lisa* as simplistic and superfluous, whereas his anatomical studies and flying machines were pivotal for me. In short, his airplane was a vision of something that did not exist, something that could not be realized at that time. That's what art is, I think: the sensitivity to project oneself beyond reality and beyond our immediate future.

As a child, then, I was fascinated by the idea of airplanes. The drawing I produced for the entrance examination of the School of Art, when I was eleven years old, was of an airport seen from above, even though I would never actually see an airport before the age of twenty-five. I'd taken note of the fact that flying is not just something physical, but a conceptual, poetic, and philosophical act. Flying doesn't just mean flying physically. It is also creating, evolving, communicating, forging connections—voyaging far from your current situation by making poetry, by making art. ▬

***Hibrido de limo Chrysler (Hybrid Chrysler)*, 2016**
1953 Chrysler Limousine with metal wings and fiberglass, 18 ft. 8⅜ in. × 6 ft. 6¾ in. × 5 ft. 10⅞ in. (5.7 x 2 × 1.8 m)
View of the work in situ at the Venice Biennale, 2017.

Pan nuestro de cada día (Our Daily Bread), 2015
Steel and painted fiberglass,
13 ft. 1½ in. × 2 ft. 7½ in.
× 2 ft. 7½ in.
(400 × 80 × 80 cm)
Private collection.

Esterio Segura Mora's
studio.

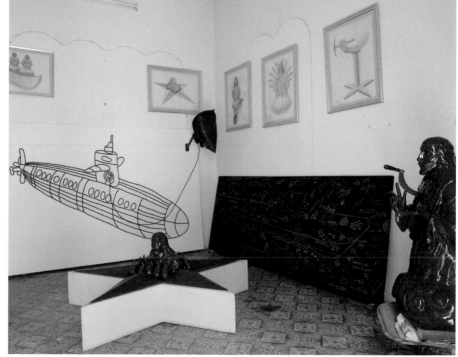

REYNERIO
TAMAYO

In essence, my universe is the universe of imagination. My work is very heterogeneous. At the beginning, when I started out, while I was still very young, I liked comic strips and graphic humor. When you look at my output, it has a lot to do with comic strips and graphic humor. Obviously, sometimes the humor in my drawings is very cruel, ironic, and at others it's subtler. But it's an oeuvre in which I'm always creating and looking for things to say.

It's not typically hedonistic, my work: you do an exhibition, then another exhibition, and all the pieces look the same. I have an abiding anxiety, and I always place humans at the center of whichever situation I am depicting. These are sometimes terrible situations, and sometimes they're very funny.

Born in 1968 in Niquero.
Lives and works in Havana.

Niquero

I don't want audiences to think highly of my work just because of its color, composition, technique, or treatment; I also want it to be full of content. I want my work to be provocative and to make people think. For me, that's what's most important. There's everything in my work: art history, superheroes, Cuban customs, famous characters, figures from art. For me, anything goes. I'm as interested in simple, commonplace things as in spectacular or truly universal events. Some of my pieces relate to the destruction of the Twin Towers, for example.

These are very sensitive subjects, but they're also unbearable. This is why one of the artists I rate most highly is Goya, because he always had his inner demons. He was not satisfied with painting the world of the court, a superficial universe, but also depicted the face of what is ugliest in humankind, in the *Caprichos*, *Tauromaquia*, and *The Disasters of War*. These are the kind of subjects I'm looking for.

I do all this with humor, because I believe that humor is a philosophy. That's how I interpret this life. It's better to laugh than to cry. What's more, it's said, that laughter does not kill brain cells, it helps create new ones. In sum, humor is a means of communication. I can have an idea for a terrifying, cruel subject matter, but humor will always soften and channel the story I'm telling, adding a helping of wit and imagination. Humor fascinates me as a genre.

The problem is that I'm constantly searching. My objective is not the end product, but to carry on searching. Max Ernst said that the day an artist says he's fulfilled, he'll drop dead.

Let's take the picture *Gulliver*, for instance. It's a funny work. Its background is political, but that's not the purpose of the piece. Its aim is to amuse us, to scoff—as Cubans do. There's something in Cuba they call *choteo*. *Chotear* means to laugh at serious things. And this is the essence of *Gulliver*. The starting

Reynerio Tamayo's studio.

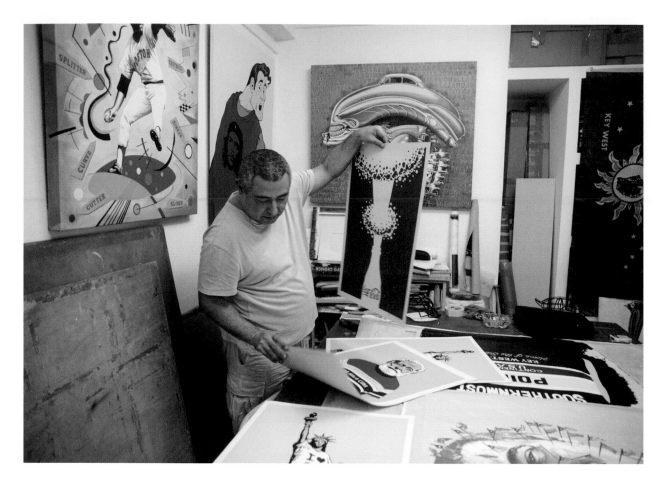

point of the piece was the moment relations were
restored with the United States, and what was the
Cuban doing? Having a party. But it's an ironic,
cynical party. That's *choteo*.

A lot of people ask me: "What's going to
happen in Cuba?" And I answer them: "Cuba has
a very strong culture; and well before relations
were reestablished, people knew already about
Superman."

My work deals with these issues and, more
importantly, encourages you to enjoy the present.
Because with the current US administration,
nobody knows how things will turn out.
Nobody—neither Gulliver nor Superman. ▬

**Reynerio Tamayo
in his studio.**

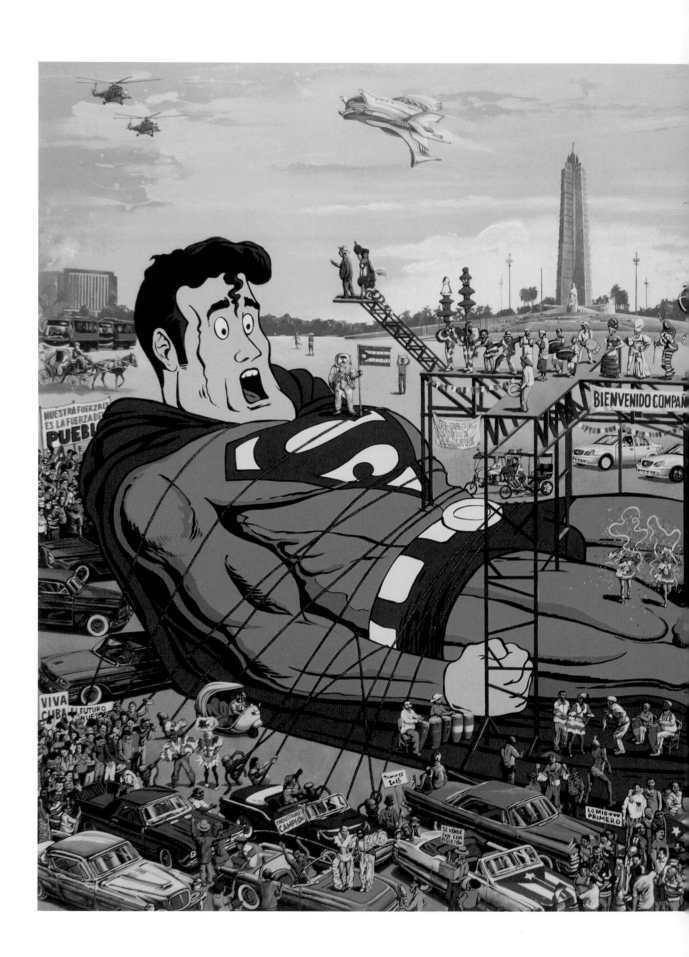

***Gulliver*, 2015**
Acrylic on canvas,
5 ft. 3¼ in. × 6 ft. 6¾ in. (1.6 × 2 m)
Private collection.

JOSÉ ÁNGEL
TOIRAC

My work is almost always inspired by photographs that already exist, whether they're lifted from newspapers, history books, or any type of published material. It's information that is already in the public domain. The creative element is when I put one image in relation to another, when I suggest different links, proposing a new point of view, a new reading that does not always coincide with the thinking or discourse of official history.

I believe that, unlike propaganda, art must ask questions rather than give answers.

**Born in 1966 in Guantánamo.
Lives and works in Havana.**

Guantánamo

Untitled, from the series *Manos*
(*Hands***), 2009**
Oil on canvas, 29½ × 17¾ in. (75 × 45 cm)
Private collection.

An elementary reading of my work might characterize it as political art, and that kind of art that inevitably has a local flavor. My first inspiration, so that my art can be credible in a logical, natural way, is life in Cuba. My works' power and truthfulness depend on that, but such an engagement does not prevent the existence of other levels of interpretation, a different way of approaching "truth," including in art that's actively political. In my case, the manner in which I weave real-life stories together with explicit references to classic literature, classical mythology, or Catholicism distinguishes it from pure political propaganda.

There is also more personal content in my work, derived from the fact that I decided to stay and live in Havana while many artists of my generation opted to leave Cuba. One cannot choose the place where one was born, but one chooses the place where one decides to live and work (or, at least, the place where one doesn't want to live and work). In this sense, my work has helped me understand my choice. I'd like to stress that this is a personal choice, a right, an individual responsibility, just as much for those who left as for those who stayed behind. So I felt the need to search for an identity through the exploration of the city where I live, immersing myself in the current of my country's history. It's this journey through the past that has led me to understand that the search for and the reaffirmation of identity do not necessarily require the building of a wall dividing what we are from others.

My more recent work, the series on which I'm working most at the moment, is the fruit of this thinking. It's a series of drawings and watercolors of the objects that surround me in

everyday life. I take photographs of them and then paint them. What is interesting here is the process: I've selected these objects from the background of pornographic photos taken from the Internet that have circulated on USB drives before reaching me. The objects I chose, like cigarettes, rum, coffee, rosaries, etc. represent a mosaic of *cubanidad*—stereotypical subjects on which the Cuban government and tourist agencies draw for advertising, so as to portray Cuba as a safe and desirable destination.

I've just hit fifty, and, in general, at that age you start looking at life from a different angle, your priorities change. You experience a great crisis, but this crisis is necessary and makes you stronger. At age fifty, I believe I'm more human than Cuban, because Cuba is not on a different planet. Like all humans, we share common defects, we're not perfect. When we seek perfection, we call upon God (it doesn't matter if it's Changó, Christ, or Allah), because

God is perfect. When we're hungry, we eat. In the morning, if we're still sleepy, we have a coffee to wake us up. With friends, we drink a beer. These are human, not specifically Cuban, situations. And once you understand that they are shared by all—that they can be reproduced anywhere in the world, and that art helps you to understand that—then you discover that to be an artist means something. Living one's life can be simple or complicated, but, fundamentally, it's always worth the bother. ▬

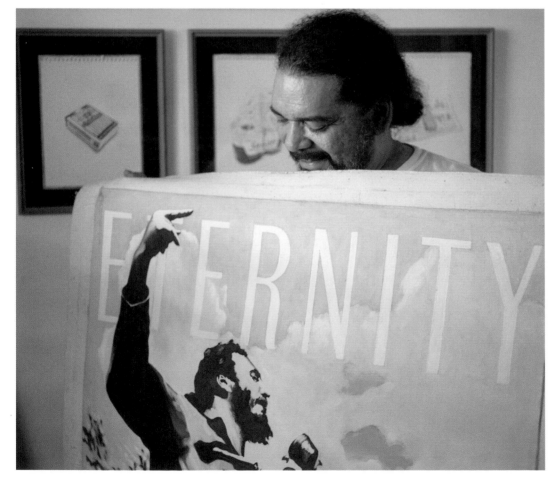

**José Ángel Toirac
in his studio.**

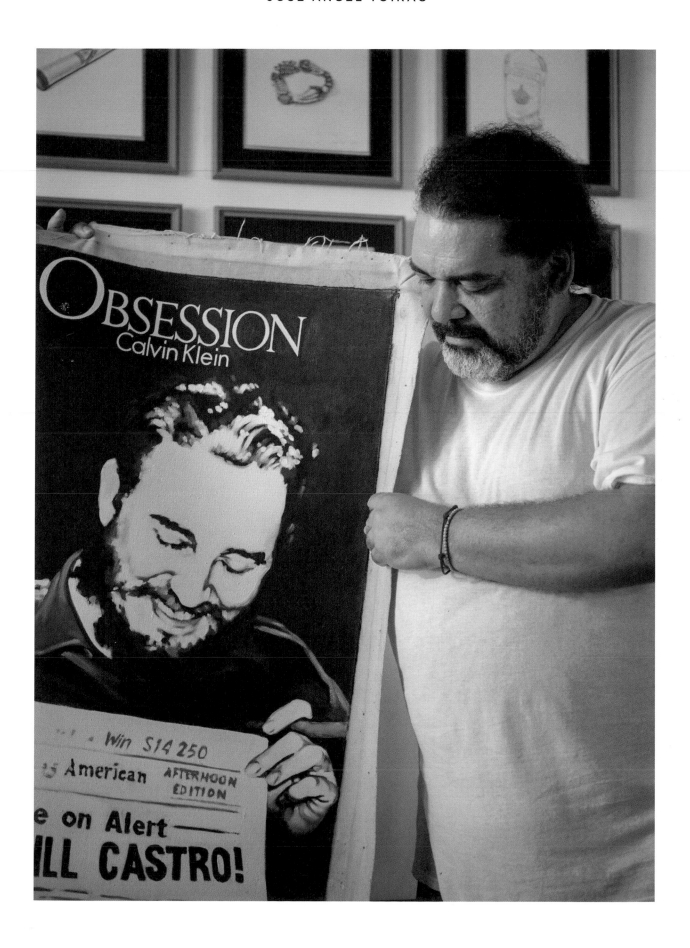

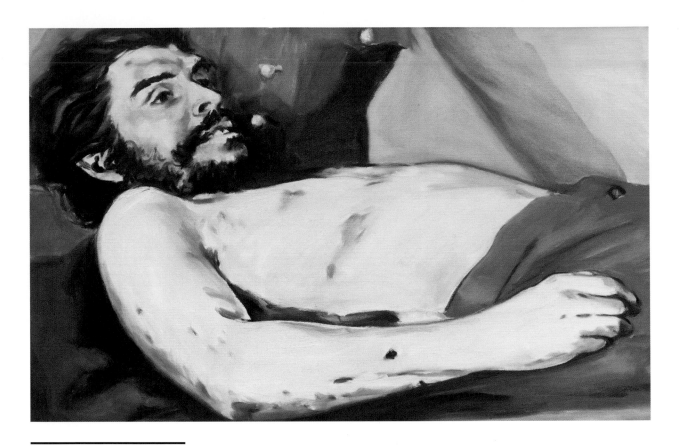

**_Aquiles y Ulises_ (_Achilles and Ulysses_),
diptych, 2010**
Oil on canvas, each 17¾ × 20½ in. (45 × 52 cm)
Private collection.

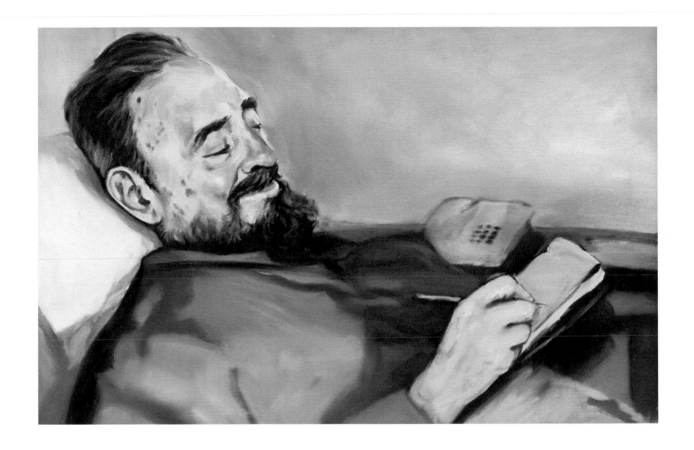

JOSÉ
YAQUE

I studied at the Carlos Enríquez academy in Manzanillo, in the province of Granma, from 2002 to 2005. In 2006, I entered the ISA, studying there until 2011. After that, I stayed on to live in Havana.

My work is rather varied. I don't like confining my ideas to any specific medium. I try to find and appropriate objects that help me express my ideas best, whatever I'm thinking about at any given moment. It is out of this constant search for ideas, for objects, that a piece is born. My major reference point is nature as the essential creative force. I've always paid great heed to nature. I see it as something of which humans form a part, like a kind of Pantheon. What fascinates me in nature is creativity. I like to see my work as a collaboration with this creation that already exists, independently of my work and of myself.

Experimentation is very important in my art. I don't begin a work knowing how it will end up. It is still waiting to be discovered, it is about to be born. Simply put, I feel a sort of urge to collaborate in the birth of a work, which sometimes doesn't come from me, but from my present circumstances, from a particular time. All this forms part of a continuous learning process; that is to say, the work doesn't originate in acquired knowledge, but in a knowledge yet to be discovered and revealed. I am the first to see it, curious about how it will emerge.

**Born in 1985 in Manzanillo.
Lives and works in Havana.**

Manzanillo

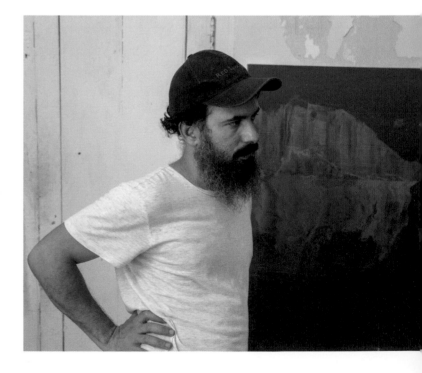

José Yaque's studio.

But to return to the idea I mentioned earlier— my refusal to be bound to any specific medium—I prefer to talk about *objects*. I think of myself as a subject, as a human being in relation to the things that surround me.

Painting is part of this same classification of objects. It's rather more abstract, a raw material, a material in transition, like an object with a defined form, such as a table, a chair, a door, a house. In other words, I try to see things as they appear before me, and not in a generic, symbolic way. This is not a *symbolic* table, it is a table. It could be symbolic, but it's just the table that's in front of me. It is simultaneously unique and generic.

My working method is rather free, open, spontaneous. As I've said, I am the first discoverer, the first to be interested, the first to be curious. At every moment, I like to remember that creation is present and that it will always be present. Simply put, I might not be part of it. It doesn't depend on whether I'm young or old: it's there, it's always occurring. You just need to open your eyes and see it. You might say that my work is a tool that helps me get to know the world that surrounds me, that helps me know reality a little more deeply. Frequently, my work is like my way of speaking, but it's also the way in which the world speaks to me and tells me things.

I guess I have a kind of addiction to creation. It gives me a very special kind of freedom, where I can emancipate my thinking, my soul, my being, to a level you wouldn't believe. Likewise, it could be interpreted as therapeutic, redemptive, life-giving, and able to do astonishing things, independently of place and time.

I believe in the capacity of the moment, and I believe in what can survive, in the results. A piece may survive or it may not (which is often the case). Often the process is intense and beautiful, yet the work comes to naught. It's like a battle during which I need to do things as if I were learning on the job.

A French artist whose name I can't recall said something that fascinates me: art serves one purpose only, and that is to teach you that life is more important than art. I believe art is a doorway, for the beholder as well as for the artist; it makes it possible to enter reality, but via another route. As I said, freedom is possible, happiness is possible, balance, harmony, peace, illumination, whatever you want to call it.

Art is definitely useful, first of all for the artist himself. I don't think I can speak about something, convey something, or attempt

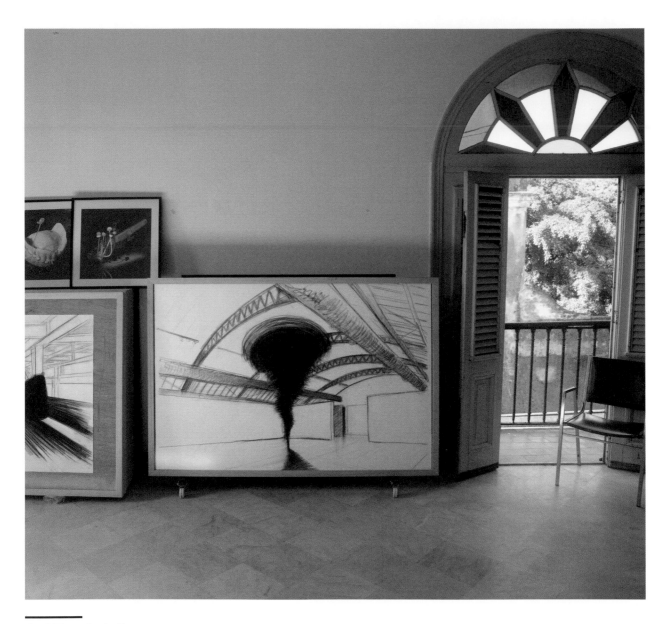

José Yaque's studio.

José Yaque in front of his work *Espodumena I* (*Spodumene I*, 2016).

something I haven't already experienced. The artist often talks about a world they're familiar with, that they live in, that they know is real.

Art changes things. I enjoy going beyond the word "art," with its connotations of "creation." The word "creation" lies outside the world of cultural institutions, escapes all confines, so that it can exist in any location, at any moment in time—in your kitchen, at home, when you're talking to somebody, when you keep quiet, when you look at a tree. Art is something quite fascinating. ▬

Ovulo fecundado se implanta en la pared del útero
(***The Fertilized Ovule Implants in the Uterine Wall***)**, 2010**
Acrylic paint, varnish on canvas, 8 ft. 2⅜ in. × 5 ft. 10⅞ in. (2.5 × 1.8 m)
Collection of the artist.

Calcantita II (Chalcantite II), 2016
Acrylic paint, varnish on canvas, 8 ft. 2⅜ in. × 5 ft. 10⅞ in. (2.5 × 1.8 m)
Collection of the artist.

ACKNOWLEDGMENTS

I would like to extend my sincerest thanks to

Catherine Bret-Brownstone, who first had the idea for the book
and whose participation was essential.

Julie Rouart (my esteemed editor), Pierre-Yann Lallaizon, Mélanie Puchault, and Sam Wythe.

Samantha Barroero, my faithful assistant.

Gloria Escobar, who transcribed the interviews.

The artists, above all, for their generosity and their confidence in the project.

And all those who contributed to the book in various ways: Philippe Costamagna, Lesbia Dubois, Jorge Fernández, Concha Fontenla, Helmo Hernández, Sachie Hernández Machín, Roger Herrera, Quique Martínez, Corina Matamoros, Isabel Pérez Pérez, Graciela Ramírez, Ignacio Ramonet, Ricardo Rodríguez, Rubén del Valle, and Gretchen and Jean-Marc Ville.

PHOTOGRAPHIC CREDITS

Editor's Note: The artists' profiles are based on a series of recorded interviews. While we have attempted to remain faithful to the original words, some differences of nuance might have occurred during the process of transcription and translation.

FLAMMARION

Editorial Director: **Kate Mascaro**
Editor: **Sam Wythe**
Translated from the French by **David Radzinowicz**
Translated from the Spanish by **Sarah Louise Bellis** (Graziella Pogolotti's essay)
Design: **Pierre-Yann Lallaizon**
Copyediting: **Penelope Isaac**
Typesetting: **Claude-Olivier Four**
Proofreading: **Nicole Foster**
Production: **Margot Jourdan**
Color Separation: **Bussière**
Printed in Portugal by **Printer Portuguesa**

Simultaneously published in French as *L'Art à Cuba*
© Flammarion, S.A., Paris, 2019

English-language edition
© Flammarion, S.A., Paris, 2019

editions.flammarion.com

19 20 21 3 2 1

ISBN: 978-2-08-020388-5

Legal Deposit: 04/2019